The Act of Drawing

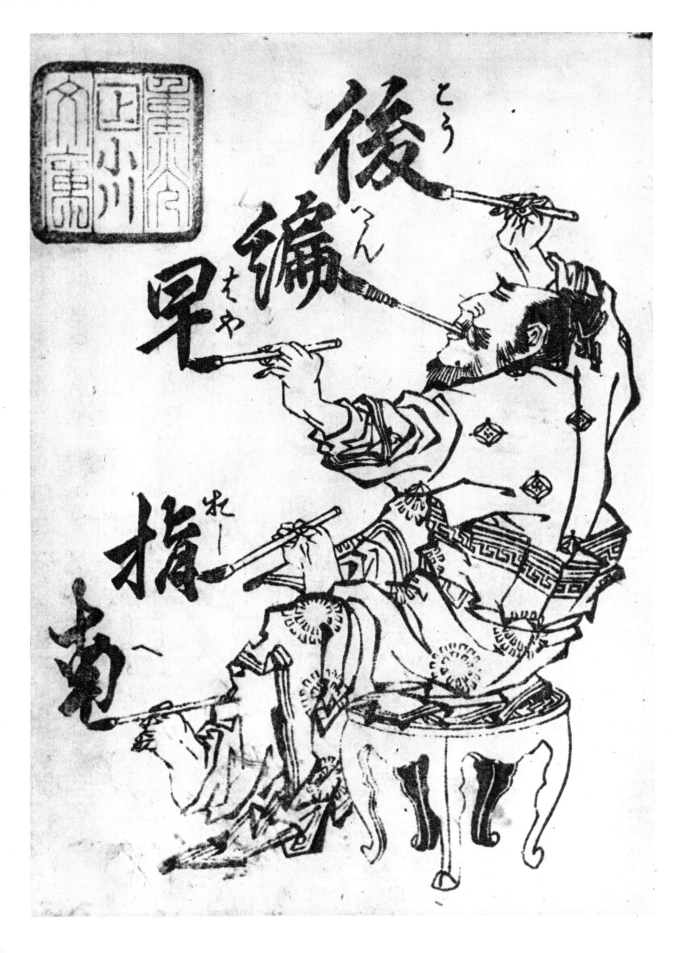

The Act of Drawing

by Edward Laning

McGraw-Hill Book Company
New York / Toronto
Mexico / Panama / Johannesburg

For Mary

Published in 1971 by McGraw-Hill Book Company,
a subsidiary of McGraw-Hill, Inc.
Produced in association with Chanticleer Press, Inc.
Printed by Amilcare Pizzi S.P.A., Milan, Italy
Library of Congress Catalog Card Number: 70-148991
SBN 07-036349-8
First Edition
Designed by Ellen Hsiao

Photo Credits
Alinari-Art Reference Bureau, 33,34, 46, 48, 49, 58, 91
Anderson-Art Reference Bureau, 18, 59, 69, 72, 74

Illustration facing title page
Hokusai:
frontispiece to volume two
of *Ryakuga Haya Oshie*

Contents

List of Illustrations 6

Introduction 9

1. What is drawing? 12

2. A word about materials 20
Paper 20
Pencil and crayon 23
Charcoal 24
Pen and ink—and brushes 26
Erasers 28
How to hold a pencil or crayon 30

3. The parts of drawing 32
Line 32
Tone 33
Shape 37
Form, modeling, light and shade 41
Texture 44

4. Learn to draw by drawing 48
Automatic drawing 49
Contour 50
Action and gesture 56
Modeling 66
Light and shade, the third contour 69

5. Inks, crayons, and drawing on colored papers 86

6. Texture and color in drawing 92

7. Foreshortening and perspective 98

8. Composition 112

9. Drawing the human figure 130

10. A great drawing 152

11. Conclusion 158

List of Illustrations

1. Cave painting, *Horse with Arrows*
2. Delacroix, Page from his sketch book
3. Ingres, *Study for the Portrait of Louis-François Bertin*
4. Ingres, *Portrait of Louis-François Bertin*
5. Preparing the paper for washes
6. Lines and tones made with a variety of pencils and crayons
7. Vine charcoal and stick charcoal
8. Lines made with pens of different gauges
9. Ingres, *Study for a Seated Nude Male*
10. Hokusai, *Rider on a Rearing Horse*
11. How to hold a pencil
12. A beveled crayon
13. Lines and tones
14. Shapes of things in tone or silhouette
15. Shapes of things in outline
16. Dürer, *Adam and Eve*, drawing
17. Dürer, *Adam and Eve*, engraving
18. Tintoretto, *The Visitation*
19. Spheres modeled from light to dark
20. Seurat, *Café Concert*
21. Renoir, *Study of a Nude*
22. Drawing textures of hair and foliage
23. Rembrandt, *View of Amsterdam*
24. Doodlings
25. Ingres, *Nicolò Paganini*
26. Van Dyck, *Study of Count Albert of Arenberg*
27. Agostino di Duccio, *Angel*
28. Picasso, *Nessus and Dejanira*
29. Toulouse-Lautrec, Page from his sketch book
30. Rubens, *Study for a Kermess*
31. Rodin, *Figure Disrobing*
32. Daumier, *Carnival Drawing*
33. Raphael, *Madonna and Child*
34. Michelangelo, *Madonna and Child*
35. Pollaiuolo, *Study for Hercules and the Hydra*
36. Rembrandt, *Woman Carrying a Child Downstairs*
37. Plumb line
38. A modeled drawing by a student

39. Renoir, *Shepherdess*

40. Michelangelo, *Study for the Battle of Cascina*

41. Forms drawn in terms of light from one side

42. Replica of *Venus de Milo*

43. Titian, *Drapery Study*

44. Cylinder, garbage can, and sack of potatoes

45. Poussin, Wash drawing

46. Tiepolo, *Martyrdom*

47. Piranesi, *Roman Prison*

48. Michelangelo, *Male Nude*

49. Michelangelo, *St. Matthew*

50. Letting the paper work for you

51. Leonardo da Vinci, *Study of Drapery on Red Paper*

52. Fragonard, *The Mouse in the Moon*

53. Rubens, *Portrait of Isabella Brandt*

54. Examples of foreshortening

55. Dürer, *The Screen Draftsman*

56. Boxes in perspective

57. Boxes and discs above and below the horizon line

58. Giotto, *Presentation of the Virgin in the Temple*

59. Piero della Francesca, *Architectural Study*

60. Vincent van Gogh, *Street in Saintes-Maries*

61. Egyptian figure

62. *Ibis-headed Figures*

63. Mantegna, *Dead Christ*

64. Rodin, *The Three Shadows*

65. Illustration after Rodin's *Three Shadows*

66. Lorrain, *Study of Trees*

67. Stuart Davis, *Pochade*

68. Giorgione, *Sleeping Venus*

69. Mantegna, *Judith and the Head of Holofernes*

70. Blake, *Wise and Foolish Virgins*

71. Leonardo da Vinci, *Mona Lisa*

72. Titian, *Adam and Eve*

73. Examples of planimetric design

74. Rubens, *Copy of Titian's Adam and Eve*

75. *Yin and Yang*

76. Titian's *Adam and Eve* as Yin and Yang

77. Diagram of Rubens' *Mercury and Argus*
78. Human figure divided into sixteen parts
79. Principal elements of the skeleton
80. The skeleton within the mannikin
81. Mannikin in various attitudes
82. The musculature of the body
83. The muscles within the sixteen-part mannikin
84. Division of the head
85. Raphael, *Head*
86. Watteau, *Study of Head*
87. Convex lines
88. Michelangelo, *The Creation of Adam*
89. Dürer, *Praying Hands*
90. *Belvedere Torso*
91. Titian, *Portrait of Pope Paul III*
92. Bruegel, *Ticino Valley South of the St. Gotthard Pass*
93. Benton, Diagrams describing principles of form organization
94. Pollock, *Autumn Rhythm*
95. Rubens, *Seated Nude Youth*
96. Rubens, *Daniel in the Lion's Den*

Introduction

This book is addressed to artists and art students as practitioners. It is not a book about art history or the psychology of art. History and psychology approach art from the outside; the concern here is with creativity and skill. This book is about the *act* of drawing.

Artistic potential is developed and perfected only by practice, initially in close association with a respected master, and by frequent and studious visits to the museum. These are the three touchstones of an artist's life: continuous *practice* (which must become so habitual that it is second nature, as taken for granted as breathing); *criticism* (the criticism and advice of a "master" will be superseded by the criticism and advice and examination of peers); and constant *study*, in the museums, of the greatest works of the past in the artist's own and related mediums.

History and psychology are worthy subjects, and there could be no objection to an artist's studying these intensively, if only life were long enough. But Art is long, and Time is fleeting. Books may be of value to an artist, or they may not; the important point is that they are not essential. It is quite possible for a great artist to be illiterate. In our time, when literacy is almost universal, he is usually able to read. Books may indeed be very important to him. An artist in any medium is usually responsive, in some degree, to works of art in mediums other than his own, and a painter or draftsman may delight in poetry and drama. He may be interested in art history, as *history*, and the psychology of art, as *psychology*. Of course, he may find the picture books very important, provided the reproductions are of good quality, even if the text is worthless or in a language he cannot read. But these books of reproductions are aspects of the museum. They constitute what André Malraux calls "Museums without Walls."

This is a book about drawing as description and delineation. Questions of spatial relations, of geometric form, are important here but not primary; they are among the conditioning factors in representation, like light and dark, or color. It is objective representation that is our subject. Furthermore, the emphasis here is on plastic rather than graphic representation. These terms had better be defined. To put it simply, *graphic* signifies extension in two dimensions, that is, up and down and across the picture surface, while *plastic* connotes some suggestion of three-dimensional extension, or movement to and fro.

The subject of objective representation in art has been confused for a long time with the visual representations of photography. It must be understood that drawing (or painting) and photography are fundamentally different. The more a photographer's work is based upon the disciplines of drawing and painting, the better it will be; the more a drawing resembles a photograph, the worse it will be. In the hands of an artist, the camera can produce works of art, but camera technique can contribute very little to an artist's development. In the early days of photography, artists had high hopes for the new instrument as a sort of laborsaving device. Eugène Delacroix was such a painter, but he soon put the new invention aside. In America, the painter Thomas Eakins was a pioneer photographer who often worked directly from his own photographs. Lacking Delacroix's base in tradition, Eakins' work was often seriously impaired by his dependence on the camera.

The camera is a one-eyed machine which can only register, mechanically, the varying degrees of light which the lens transmits to film. Drawing must do much more than this. In fact, the tonal relations of the photograph are but one of the means at the disposal of the draftsman—and not the principal means, either. Line is more important than tone.

The "imitation of nature" is an extremely complex idea. It cannot mean "copying nature," for that is manifestly impossible. At any rate, we cannot reproduce a tree, an animal, or another human being by means of marks

made with a burnt stick upon a piece of paper. The concept of the imitation of nature does, however, have real significance if we understand what it is we can and cannot do. Hamlet urges the Players "to hold, as 't were, the Mirror up to Nature; to show virtue her own feature, scorn her own image, and the very age and body of the time, his form and pressure." The essence of the matter lies in that "as 't were."

Like Hamlet's Players, we are playacting, we are pretending. And like the dramatist and the actor, we are using a language. Ours is not a language of words, but one of lines, textures, and tones. We use these technical means symbolically. Ours is a language addressed to the eye as the poet's is addressed to the ear. We are not involved in copying nature, but in constructing a reality parallel to nature. Our symbols are directed to the mind through the eye, but they are concerned with much more than the merely visual aspects of nature. Our lines, tones, and colors are visual equivalents of a profounder sense: the sense of touch. A good drawing invites the spectator to touch, to feel, to stroke, to grasp. It conveys a wealth of information concerning weight, density, balance, movement, color, texture, and coherence—qualities which the visual sense alone could not apprehend.

In the words of the great French artist, Ingres: "Go on drawing for a long time before you think of painting. If one builds on solid foundations, one sleeps untroubled."

1.

What is Drawing ?

Drawing is as old as mankind. The drawings of animals on the walls of prehistoric caves are as good as any drawings made in the thousands of years since. Drawing changes a little in manner and style from one historical period to another, but these variations are more important to historians than to artists. From the artist's point of view, drawing has no history, only practitioners. The artists of the Lascaux caves or the painters of Greek vases would perfectly have understood Giotto and Michelangelo, Rembrandt, Goya, and Daumier. Even our materials have hardly changed at all—a few simple pigments mixed with glues or resins; brushes made from hairs or bristles attached to the end of a stick; and bits of burnt wood. Even paper our most recently developed material, has been available since the Middle Ages.

To draw is "to delineate; sketch, portray, as with pen or pencil; also to mark or define in words." The dictionary does not tell us much that we don't already know. To mark or define. We draw with a gesture when we indicate a measurement by holding our fingers or hands a certain distance apart, by holding our hand a certain distance above the floor, or by suggesting a shape with a motion of our hands and arms. Perhaps we can say that all meaningful motion is drawing. A priest draws the cross with a gesture of his hand in the air; a dancer draws with his whole body in space. Leonardo da Vinci advised artists to study the gestures of deaf mutes to find expressive attitudes. Here was a supremely skilled draftsman learning from simple and primitive expressions—Leonardo was returning to the basic sources of his art.

To make marks, lines, or smudges on a plane surface is to draw. The act of drawing is the execution of meaning- ful marks, lines, or smudges in more or less permanent form. We draw with our finger on a frosty window pane and the lines evaporate. We draw in the sand with a stick,

and wind and wave obliterate our markings. We draw on a blackboard with a piece of chalk and erase our marks to make a clean slate for other drawings. If, however, we draw on a piece of good paper with a burnt stick (charcoal), we deposit bits of carbon which can be "fixed" and preserved by applying a spray of clear varnish. Or we may make our markings with a carbon ink on rag paper and our drawing can last indefinitely with proper care.

Why do we draw? Drawing can be a means of communication—a language—and we use it as such. It is often said that a picture is worth a thousand words. But the impulse to draw is probably deeper than the desire to communicate, and issues from the artist's desire to project and hold a mental image or fantasy. This mental image often seems intensely vivid, but the artist finds, when he tries to put it on paper with pencil or crayon, that it is actually very vague. What he is able to sketch out will usually be a pale and inadequate projection of the original image, but this feeble sketch will stimulate further imagining and the drawing will proceed to develop almost like a growing organism so that it sometimes seems to the artist to draw itself; the drawing assumes a life of its own, as it were, independent of its maker.

Drawing can be used as a means of gathering and recording information. We can draw anything we see, anything of which we can form a mental image. We can draw descriptive representations of objects, and artists have always used drawing to make studies of objects before painting them, by posing models in attitudes corresponding to those in the artist's original mental image, sometimes finding in the models' positions or gestures better configurations than those originally conceived. Since the invention of photography, a confusion has developed in this matter of representation, imitation, or "copying."

Let us consider what we mean by seeing in relation to drawing.

What do we see? The eye perceives patches of color—no more. Because we have two eyes and the left eye sees a little more of the left side of an object and the right eye a little more of the right side, we have some direct perception of three dimensions, but not much. With the aid of memory our minds relate the color patches, which the eyes perceive, to data gathered by the other senses—especially the sense of touch, from which all our senses originally derive. An infant does not see chair, table, or bed. He learns about these the hard way by bumping into them and falling down. Patches of color become a coherent object—a toy—for example, when he discovers by reaching out that the colors are properties of something having weight and volume, texture, taste, and smell. As he gains experience, the child learns to make his way across a room without mishap, identifying objects at a glance. He names things, and soon the patches of color become little more than signals which his brain interprets as chair, table, toy, mother. At an early age he may cease (for all practical purposes) to see anything at all. He may live fairly adequately in a world of abstract symbols and signs—signals for food, warmth, sex, sleep.

Drawing exactly parallels this development. It is obvious that we cannot copy, cannot imitate, what we see. We would produce nothing but patches of color. We draw in black and white, and this is the way we dream but not the way we see. We draw with lines and with tones, and these marks, lines, and smudges are visual symbols of mainly nonvisual experiences. In a sense we must dream the object before we can draw it; at any rate, it is our mental image of the object which we can transcribe to paper, and not the object itself.

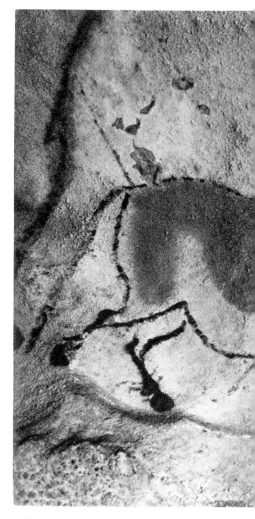

From an artists point of view, these drawings, though separated by thousands of years, are contemporary with each other.

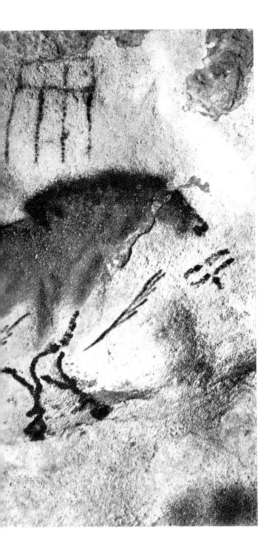

1. Cave painting,
Horse with Arrows
ca. 15,000–10,000 B.C.
Lascaux, France

2. Eugène Delacroix
(1798–1863)
Page from his sketch book
Private collection

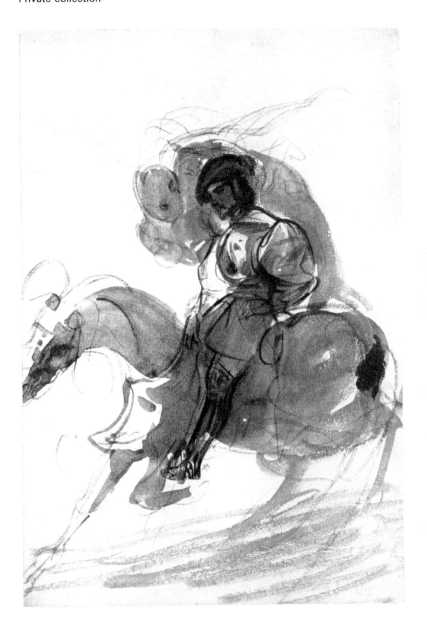

Drawing is not visual imitation. It is not a matter of copying light and shade. It is rather a matter of setting down symbols and signals of touching, feeling, clutching, grasping, stroking. When we draw, our hand makes marks upon the paper which *stand for* touching, stroking, grasping. Our lines and tones search out the surfaces of the body we are drawing, they explore these surfaces with relation to the underlying muscles and bones that produce the bulges and hollows which we feel, and they do this by finding equivalents for those surfaces in terms of softness and hardness, smoothness and sharpness, projection and recession. The line we draw flows along the undulating surface of a muscle or hooks sharply around a bony joint. The most beautiful and lively drawing will be the one in which the hand and eye are most perfectly coordinated with the sense of touch; this coordination can only be achieved with long discipline and practice. John Sloan, a great American artist and the best teacher of drawing I ever knew, used to tell us: "In my ideal art school the model would be posed in the other room in pitch darkness. To gain the information you need for drawing you would go into the other room and feel over the form of the model, then come back and put down in terms of black and white what you learned. When you ran out of information, you would go back and touch and feel and grasp the form again."

Drawing is a language, and our lines, marks, and smudges are, to our language, what letters are to a writer's. But words are not things; the name of a thing is not the thing itself. A drawing is made of symbols and is a symbolic representation of reality. Any language presupposes a society—for the most part our symbols are not invented by ourselves but are received from others. We accept them and share them. The average man is content with the names of things; he does not wish to contemplate or

enjoy objects, but to use them. The name is enough for him; he is more interested in counting chairs and houses and men and women than in knowing them. An artist must be both child and man in this respect. He does not remain altogether an infant staring at color patches, though he does see these and find them fascinating; nor is he content to dismiss the object with a name or a stereotype. He accepts the received image or symbol but he insists on examining it, taking it apart, and putting it together again, rearranging it, and playing with it.

The symbols which the artist uses can become exhausted and shopworn, just as words can, and thereby lose their power to evoke reality. Usually it is sufficient to put these worn-out symbols aside for a while and search for fresher terms. The abandoned signs and signals are nearly always "rediscovered" later and given a new lease on life. The history of photography provides a curious case of arrested development.

Photography was invented in the mid-nineteenth century at a time when drawing and painting were artistically at a low ebb. The dominant style of the time, exemplified in the paintings which filled the annual Salon exhibitions in Paris, was a tedious "naturalism" which achieved its effects by a meticulous rendering of light and shade. I doubt if photography could have been invented at any other time: the necessary industrial technology was there and coincided with a contemporary appetite for a mindless matching up of lights and shades, with the artist turning himself as nearly as possible into a sort of light meter for registering precise degrees of reflection. It was discovered that what the artist was doing, a machine could do, and then, with the machine, anybody could do it.

This rendering or "copying" of light and shade, which is

photography, is nothing more than a convention. Lawrence of Arabia has told how he used to spend idle hours in camp in the desert making portrait sketches of his Arab followers. Out of curiosity they would look at what he was doing and would pass his sketch from hand to hand. It meant nothing to them and they had no idea how to hold it right side up. In the same way we are told by explorers that Australian bushmen can make nothing of a photograph. They do not share our convention, our mutual agreement, as it were, that patches of light and shade represent reality.

The result of this invention was the creation of a sort of vested interest in a particularly debased style of art. A kind of mechanical ''copying'' became established as ''realism.'' The style of the Paris salons of 1850 was fossilized and became the commercial art which has persisted to this day. For artists it was the return of the ice age; their audience was seduced by a gadget. They retreated in despair to the color patches of their infancy and left all representation to the businessmen and their customers.

John Sloan used to come to the Art Students League at the beginning of the term, fix his class with a stern look, and say: ''Now if anyone has come to this class with the idea that he'll ever make a penny out of anything he learns here, get out!'' And a few always picked up their pencils and paper and headed for the door, while the rest of us remained to learn to draw.

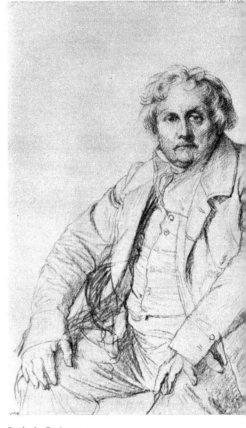

3. J. A. D. Ingres
(1790–1867)
*Study for the Portrait of
Louis-François Bertin*
chalk and pencil
on pieced paper
13 3/4″ × 13 1/2″
Metropolitan Museum of Art
Bequest of
Grace Rainey Rogers, 1943

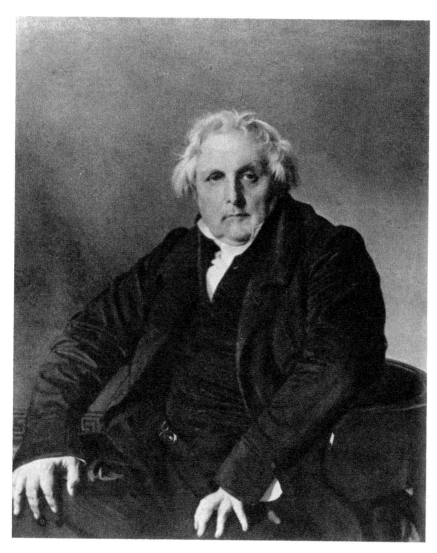

4. J. A. D. Ingres
*Portrait of
Louis-François Bertin*
oil on canvas
Louvre, Paris

Notice how in the painting of this subject, as opposed to the drawing, the arm of the chair has become the fold of the coat, but for the most part, Ingres has made only minor modifications of his original conception.

2.
A Word About Materials

The better the materials you use the better your drawing is likely to be. Artist's materials, even the best of them, are not costly, and a beginner would do well to acquaint himself early with the full range of his instrument—his papers, pencils, crayons, pens, brushes, and erasers.

Paper
The best paper is all-rag paper of a substantial weight. This can be obtained at good art stores in single sheets or bound into watercolor blocks. Learn the difference

between cold-pressed paper and hot-pressed paper. The first is rougher in texture and is suitable for broader, sketchier drawing with crayon or wash; the second is smoother and is preferable for finer work with graphite pencils or pens.

Single sheets of good paper should be stretched in order to avoid wrinkling if you wish to use washes of diluted ink or of watercolor. Dampen the paper thoroughly and evenly with a brush or sponge until it has expanded

slightly; lay it carefully on a drawing board and hold it in place with strips of gummed paper one-and-a-half inches wide. Let the strips of gummed paper overlap the edges of your drawing paper about half an inch. As the paper dries it will shrink to a perfect flatness, and subsequent washes of tones of ink or watercolor will not leave it wavy or wrinkled. A piece of paper stretched in this way should be carefully cut away from the drawing board when the drawing is finished. Use a razor blade and a straightedge, taking care that the tension of the dried paper doesn't cause it to tear when you are cutting it away from the board.

A straightedge is a bar of metal with a reliable edge to guide a pen, pencil, or blade in drawing or cutting a straight line. Drawing boards are sold in all artists' supply stores, or you can cut Masonite to the size you desire, using the smooth side for your paper.

Illustration board is drawing paper mounted on cardboard. This will provide a good paper on a rigid support to prevent wrinkling or buckling. However, the cardboard backing will disintegrate in time.

Well-bound pads of drawing paper will afford sufficient backing for ordinary use. *Bond paper* is paper of superior quality and whiteness which stands up well under erasure. It is more expensive for practice work than *newsprint*, but a little experience will quickly show how much more "sympathetic" good paper is than bad. Newsprint is very soft and coarse. Its fibers often pull away and become attached to your pencil or crayon, which then begins to skate over the surface without leaving any marks. Newsprint deteriorates rapidly and should be avoided, even for practice work. It may be that the drawing you make on it will be the very one you want to preserve!

Charcoal paper is distinguished for its texture or "tooth," which catches and holds the grains of charcoal. It is available in a wide range of color tones (many of which fade, unfortunately, with exposure to light). This paper also provides an ideal surface for all chalks and pastels, such as conté crayon and Nupastel.

Pencil and crayon
"Lead" pencils are not made of lead but of graphite, a form of pure carbon. Graphite drawing pencils are manufactured in a wide range of hardness and softness. The softest are almost pure graphite; the harder are produced by the admixture of clay. Graphite is a subtle and flexible medium of a rather delicate character. Its darkest tones are not very black but a dark gray. The harder grades—H—are useful for very delicate, precise lines, and the softer—B—for darker, richer, coarser lines and tones. A range from HB (medium) to 2B is adequate for most purposes.

Compressed carbon pencils and crayons will produce richer blacks. Good grades of the latter are the French *conté* pencils and crayons and the English *Wolff* pencils. Conté pencils and crayons are also made in red (sanguine), white, and brown (sepia). Use carbon pencils for line drawing; crayons for broader tones.

Faber's *Nupastels* are excellent drawing crayons and are available in a wide range of colors. But for purposes of drawing, these four colors are sufficient: black, white, red, and brown. These will provide the two contrasts which are enough for drawing: the essential contrast between light and dark (black and white), and the additional contrast between warm and cool (the warm colors of red and brown and the cool colors of black and white).

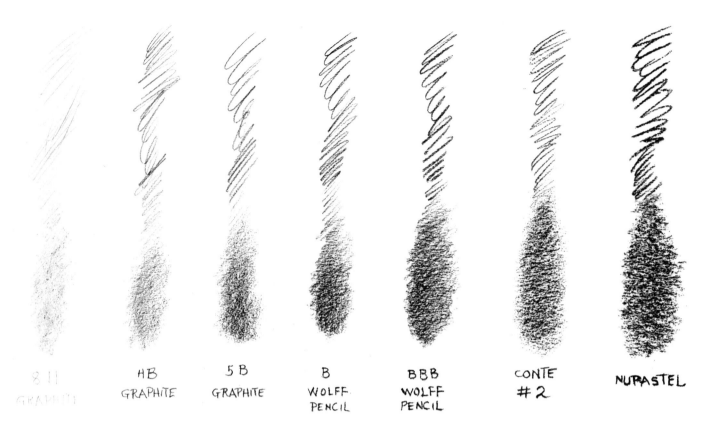

8 H
GRAPHITE

HB
GRAPHITE

5 B
GRAPHITE

B
WOLFF
PENCIL

BBB
WOLFF
PENCIL

CONTE
#2

NUPASTEL

6. Lines and tones made with a variety of pencils and crayons.

Charcoal

Charcoal (made by heating sticks of vine, willow, et cetera, in the absence of air) is a flexible drawing instrument which allows for erasures and corrections more readily than pencils or crayons made of graphite or compressed carbon. By using charcoal, a beginner will soon grasp the essential physical property of all drawing: that particles of pigment are rubbed off and deposited within the interstices of the fibers which compose the paper.

Most drawing crayons consist of a pigment, such as carbon or red iron oxide, mixed with a binder, such as gum arabic. Pastels, inks, and watercolors are all made by grinding dry pigments with glues or gums, differing only in the colors and the strengths of the binding mediums.

24

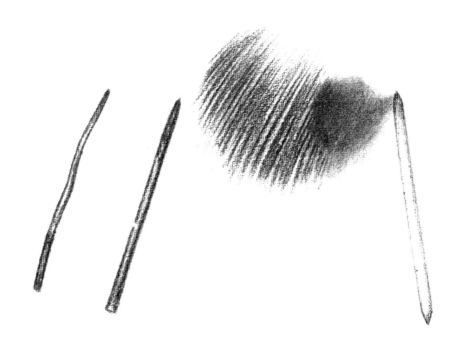

7. A piece of vine charcoal and a piece of stick charcoal. The charcoal lines are drawn on charcoal paper and blended with a paper shading stump.

Because of these binders, such mediums are difficult to erase. But charcoal particles are inert; they are not bound to the paper surface but are held loosely in the meshes of the paper fibers; thus they are easily shaken off, erased, blurred, or smudged.

Charcoal paper, already mentioned, is made expressly for charcoal drawing. It has a relatively sharp texture or tooth. Charcoal sticks are sold in varying degrees of hardness, from very soft to very hard. A sandpaper pad is useful for sharpening the sticks to the kind of point the artist desires. *Stumps* made of rolled blotting paper are employed to blend and tone charcoal lines into more subtle shades. *Fixative* is a form of varnish which is sprayed on charcoal or chalk drawings, or pastels, to prevent their smudging or powdering off. Fixative provides charcoal, pastel, graphite, and chalk with the binder which oils, gums, or glues give to paints. The artist can make his own fixative by diluting white shellac in two or three parts of alcohol and applying this solution to his drawing by spraying it with an atomizer, or he can buy fixative ready-made in pressurized spray cans. A "workable" variety of fixative will prevent the charcoal or crayon drawing from smudging or rubbing away, but will still permit erasures and reworkings.

Pen and ink—and brushes

The best ink for drawing is an artist's carbon ink. One kind, India ink, is very black, permanent, and waterproof when dry. There are also washable varieties of carbon inks (Engrossing ink, for example) which are useful for special purposes. They dilute with water more readily, and tones made with them can be, to some extent, blended, blurred, and made to "bleed" by water applied with a brush. Brown and sepia inks tend to fade.

Artists' drawing pens are available in a great range of size and flexibility. Learn by practice the different qualities of line which can be obtained with nibs of the different gauges ranging from fine crow quills to blunt points. Several excellent artists' fountain pens are available which can be filled with India ink and which take nibs of different degrees of fineness and flexibility. These flexible nibs are the only pens an artist should use. Ball-point pens are for bookkeepers. Do also try out the broader effects of a reed pen.

Spend a little more for good watercolor brushes. Sable brushes are the best, and very expensive. Don't let paint or ink dry on your brushes after using them. A properly cared-for brush will last indefinitely and serve you better. Whistler urged artists to treat their brushes and pens as the violinist treats his instrument. A sable brush is your Stradivarius!

In brush drawing, experiment with the difference between inks and watercolors. You will find that India ink is excellent for line drawing when used undiluted, but that with the addition of water to make a lighter tone or "wash," it may become grainy. Watercolor dilutes more successfully, more smoothly.

Experiment with Chinese brushes (available in most

STEEL
"CROW QUILL"

8. Lines made with pens of different gauges.

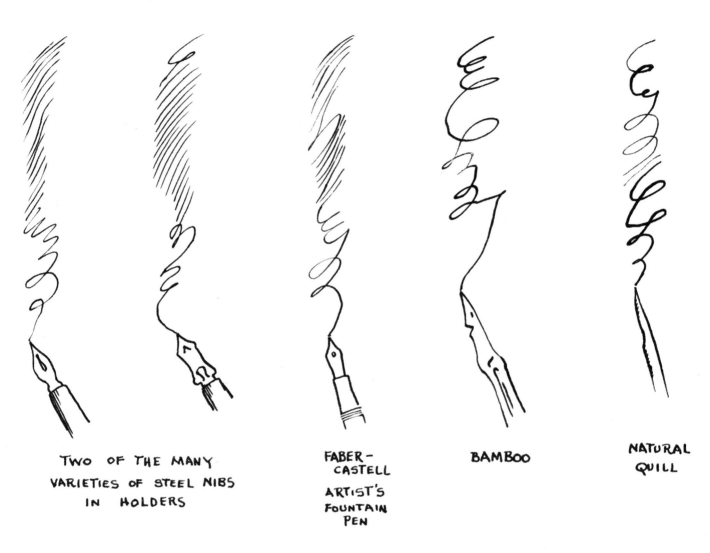

TWO OF THE MANY VARIETIES OF STEEL NIBS IN HOLDERS

FABER-CASTELL ARTIST'S FOUNTAIN PEN

BAMBOO

NATURAL QUILL

artists' supply stores) and Chinese "stick" ink. For this you should have a Chinese soapstone palette. The ink stick is rubbed on the soapstone with a little water until the desired degree of grayness or blackness is obtained. This Chinese ink, used in thin washes, has a beautiful transparency.

9. J. A. D. Ingres
*Study for a
Seated Nude Male*
black chalk
11 1/2″ × 14 15/16″
Metropolitan Museum of Art
Rogers Fund, 1961

10. Hokusai (1760–1849)
Rider on a Rearing Horse
Private collection

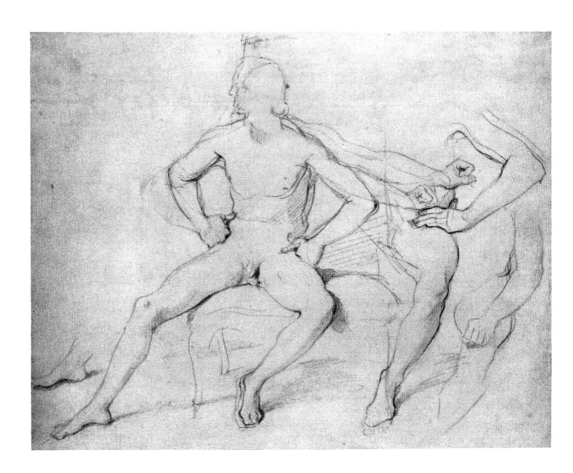

Erasers

Erasers are an admission of failure, but we can't always succeed. *Art gum* is reliable but leaves crumbs and particles behind which must be brushed away—and their removal can cause the smudging of other parts of the drawing. *Kneaded* erasers pick up and retain the graphite, carbon, or chalk particles and are cleaner. By pressing with a kneaded eraser, it is possible to pick up unwanted lines and tones by a kind of blotting process, without the sort of smudging which most erasers cause. A kneaded eraser can be shaped to a point for finer work in small areas.

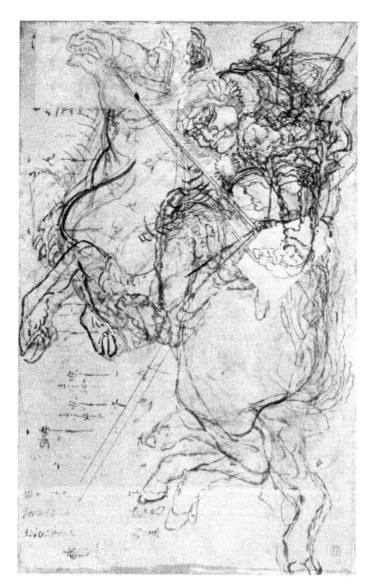

Drawings with pentimenti. In the Ingres drawing, notice the alternate positions of the figure's left arm, the corrected contours of the foot, arms, and shoulders. In the Hokusai sketch, the hind legs and tail of the horse have been corrected several times, producing an effect almost of cinematic movement.

Certain harder rubber erasers will clean more thoroughly, but any eraser will do some harm to the paper surface. The ideal procedure would be to proceed without erasing. If your line is in the wrong place, draw a better one and leave the original one alone. The drawings of the greatest artists, from Michelangelo to Hokusai, exhibit these *pentimenti* ("repentances"). Go ahead and make another drawing. And another.

How to hold a pencil or crayon

A beginner is often unsure of the "correct" way to hold a pencil or crayon. This is surely a personal matter, but two basic positions can be indicated, as illustrated here. The first is the way a pen is held in penmanship exercises; the second resembles the way an orchestra conductor holds his baton. The first is a good way to draw a line, a contour. The second is a good way to lay down a tone. The author finds that he has developed the habit—useful to *him*—of skating on the nail of his little finger. This minimizes smudging and provides a degree of leverage on pencil or crayon.

Pencils and crayons should be kept trimmed and sharpened. To sharpen a pencil, hold it in your left hand. Hold your blade with your right, directing the edge against the shaft of the pencil. Push the blade with the thumb of the left hand while directing it with the right.

To sharpen a square crayon (conté, Nupastel, et cetera), bevel the end to a wedge shape.

You cannot draw with the wooden shaft of a pencil after the graphite or carbon has been worn away. Very short crayons and pencils should be discarded. If the pencil is too short, you cannot see the drawing point. You can't draw with your knuckles. Holders are available in the art supply stores which will extend a short pencil or crayon to usable length.

The uses of the artist's drawing materials will be further developed as we proceed.

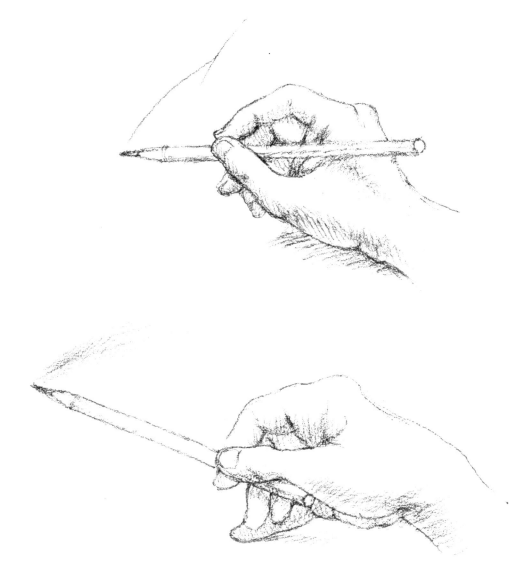

11. Here are two usual ways to hold a pencil: one, as a pen is held in penmanship exercises; the other as a pointer or baton is held. The first is a good way to draw a line; the second to lay down a tone.

The Parts of Drawing

There is a language of drawing with a grammar and a vocabulary of its own. We speak of lines and tones, shapes and forms, modeling, light and shade, and texture.

"*Lines?* I see no lines!" said Goya, one of the greatest masters of line. He meant that there are no lines in nature—that line is an idea, an abstraction. We use lines to enclose shapes and to indicate direction, as when we draw simple shapes like triangles, circles, squares, or draw an arrow to direct attention to movement.

Tones are gradations of light and dark, from the highest light to the deepest dark.

Shapes are two-dimensional areas. A silhouette tells its story entirely in terms of shape.

Forms are three-dimensional objects having extension in every direction in space—height, breadth, and depth.

Modeling is the process of creating the suggestion of form, or three dimensions, by means of gradations of tone.

Light and *shade* (or shadow) refer to the reflection of light from the surfaces of objects.

Texture refers to tactile properties such as smoothness, roughness, hairiness, et cetera.

Make a series of experiments with these various properties. Try your hand at working with these elements of drawing.

Line

On a sheet of white paper draw lines with pencil, pen, and crayon. Try different pens from the finest crow-quill pen to the stubbiest reed pen or felt point. Contrast the even, unvarying line of a ball-point pen with the greater range (from narrow to broad) that can be obtained from a flexible penpoint with the same stroke. Draw lines with

watercolor brushes—make bold coarse lines with a large brush and fine ones with a small one. Buy some Chinese stick ink with a stone palette or reservoir and note how this water-soluble ink, applied with a brush, will provide an infinite gradation of lines, from the faintest grays to the most solid blacks.

Take a black crayon (conté or Nupastel) and bevel its end to a wedge shape with razor blade or sandpaper pad. Make lines of varying widths within the same stroke by turning the crayon from the flat square side to the edge.

Tone

With pencil, crayon, or brush draw bands of tone across the paper from the blackest black to white. Draw a series of light parallel vertical lines across the page and turn these vertical bands into bands of varied tones: a black band, a light gray, a darker gray, a white, et cetera. See how many distinct vertical bands of different grays you can make. Do the same thing with washes of watercolor

12. A beveled crayon and the lines made with it from broad to fine. Use a sandpaper pad to give the crayon a beveled end.

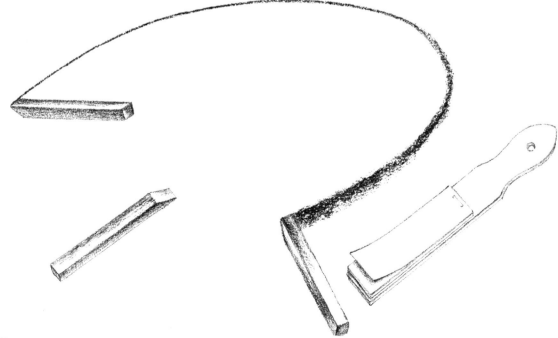

black or diluted ink. With pen or pencil produce tones by *hatching* with line (hatching is the production of tones by a series of parallel lines). Go from lighter to darker tones by *cross-hatching*, that is, by drawing another series of parallel lines over the first.

Produce different tones (different degrees of darkness from the lightest grays to the blackest blacks) by as many methods as you can. Use the flat side of a crayon and the point of a pencil. Notice how, using crayon or charcoal, the grain or "tooth" of the paper serves to produce dots of black and white on the surface. The harder you bear down on the crayon, the more you will fill up the paper's texture and the darker your tone will become. Contrast this dotting or stippling (which the texture of the paper produces automatically) with the diamond shapes of the white paper (which you create by means of cross-hatched lines) and notice that in cross-hatching these white spaces between the lines have greater sparkle and direction than the white dots which the paper alone provides. It will help you to understand the uses of various drawing media if you will look at your tones with a magnifying glass.

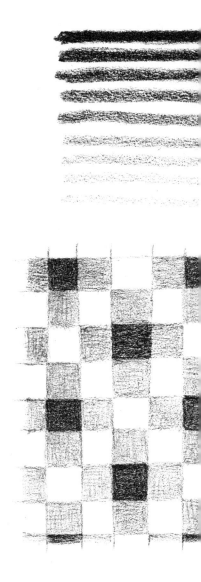

These tones, these variations of light and dark, serve several important purposes in drawing. Differences in tone give "separation"; they distinguish one shape from another and are essential in establishing *pattern*. Tone can serve to produce *color* in drawing. For example, in areas where we expect variations in color, as in hair, eyes, cheeks, and lips, a darker tone will suggest ruddiness and a lighter one pallor or blondness. Finally, tone plays an important part in *modeling*, or the suggestion of a third dimension. (This use of tone is discussed under "Form—modeling—light and shade.")

13. Practice making lines and tones. This will familiarize you with your tools and the results they can produce

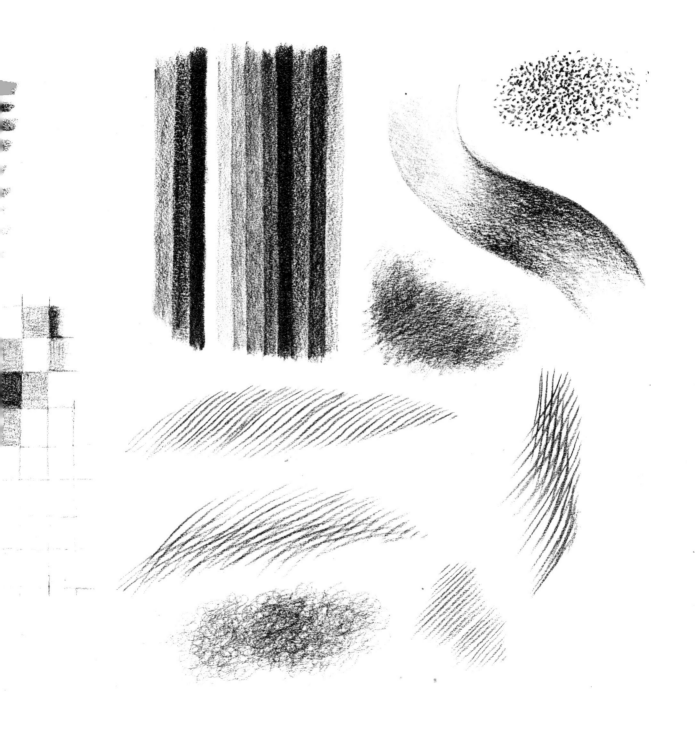

14. Shapes of things in tone or silhouette. Shapes should be clear and self-explanatory. For an example, the shape of an open hand tells its story at a glance. It "reads" well, whereas the silhouette of a closed fist, without interior articulation, would be nearly meaningless.

15. Shapes of things in outline.

Shape

Study the shapes of objects. Notice that some objects have clear, meaningful shapes and some do not; some can be "read" as shapes and some cannot. Note that a human head has a more meaningful shape in profile than in full face; a body's shape can be read easily if it is arranged as the Egyptians treated it: head in profile, torso full face, arms and legs, and hands and feet in profile. When the body huddles with arms and legs drawn in and head held down, it presents a shapeless mass. The silhouette of an outstretched hand with fingers separated presents a clearly recognizable shape; a clenched fist does not—it requires complex inner articulation to be readable.

Draw shapes of things. Discover for yourself the objects that have significant shape. Note that shapes which spread out, extend, and radiate are easy to comprehend at a glance. The shapes of wine glasses which spread out, narrow in, and spread again are easy to understand. Draw the shapes of leaves: oak, maple, elm, grape, et cetera.

Draw the shapes of things in outline. Note that shapes which spread out, extend, radiate, and which widen and narrow and widen again are easy to comprehend at a glance. Draw the shapes of stars, crescent moons, bottles, wine glasses, flowers, leaves. Contrast the shape of a tulip with a daisy, an oak leaf with a grape leaf.

This is Dürer's study for his famous engraving of Adam and Eve. In his preliminary drawing, Dürer made sure that his figures were vivid and comprehensible for shape alone, before he proceeded to develop their relation to other forms.

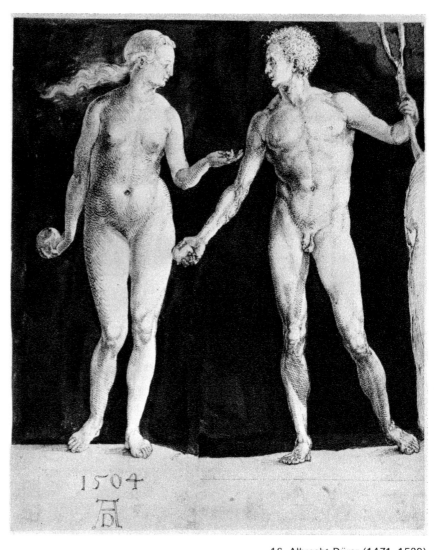

16. Albrecht Dürer (1471–1528)
Adam and Eve
drawing
The Pierpont Morgan Library

17. Albrecht Dürer
Adam and Eve
engraving
Metropolitan Museum of Art
Gift of Mrs. William
H. Osborn, 1967, in memory
of Johnston L. Redmond

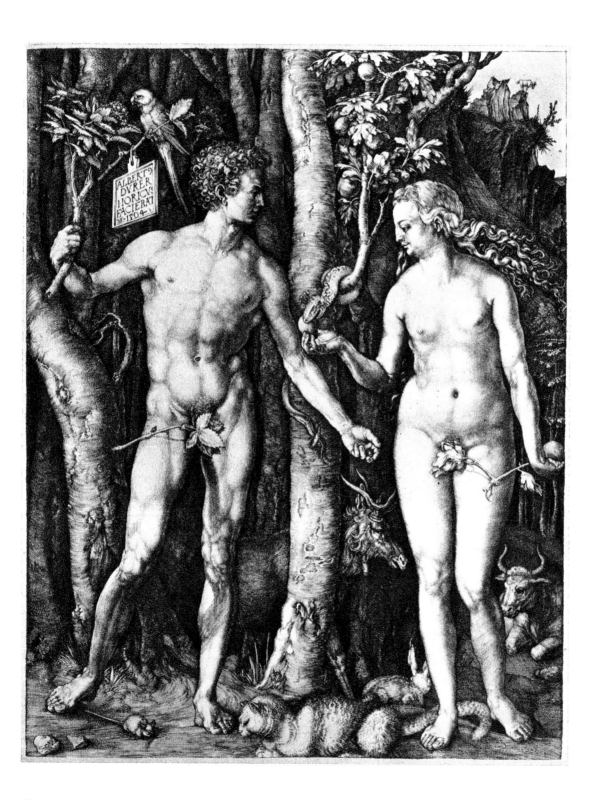

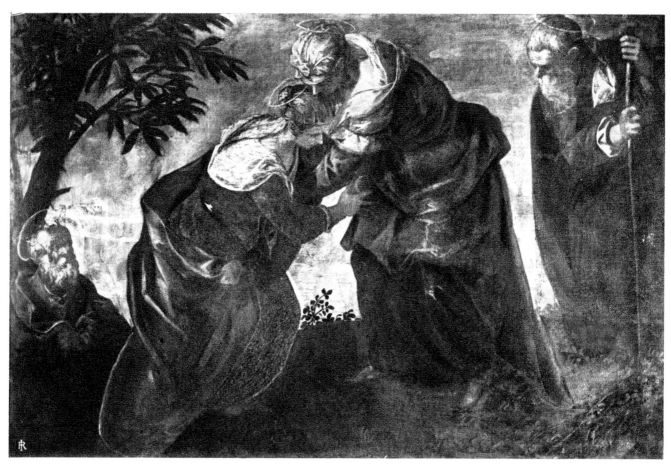

18. Tintoretto (1518/19–1594)
The Visitation
oil on canvas
Scuola di S. Rocco, Venice

Notice the importance of simple shapes in this painting: the shapes of the two women leaning toward each other, the comparatively static shape of the vertical figure at the right, and the shape of the tree and leaves at the left. Tintoretto was a master at using this type of bold silhouette to make forms project.

Form—modeling—light and shade

Break a conté crayon in half and, using the flat side, draw a sphere. First do this by working from a light center toward a dark periphery. Then reverse this procedure and darken the center of your circle and work in gradations of gray toward light edges. (Darken the background around the circle to make the edges look light.)

In the first of these spheres, you are saying that light projects and dark recedes; in the second, you are saying just the opposite of this—that dark comes forward and light goes away. Examine these modeled spheres and observe that in both cases you have drawn a half-sphere. Is it, in either case, a bulging form or a hollow one? A little further work on either one will turn it either way.

In these exercises we have been modeling our forms from light to dark or dark to light. In terms of light and shade it is as if in the first case the source of light were directly in front of the object; in the second, as if it were directly behind. Now try a third method of modeling—as if the light were from one side. Place a tennis ball or a white egg on a piece of white paper and light it from above and from one side and then draw it in terms of the light and shade which you observe. In this case you darken not the furthest edges of the form, and not its nearest point, but one side of it. This is *light and shade*, if you please. Only it isn't! And in the next section I hope to resolve this pesky matter of light and shade once and for all and avoid forever the pitfalls of photographic copying. For the great difficulty where the terms "light" and "shade" are concerned is in the confusion of means with ends. Light and shade may give you clues to the apprehension of form and may suggest means for grasping and "realizing" it, but they must be allowed to remain hints of something beyond themselves and not treated as ends. We must try to draw *things*, and light and shade are not things.

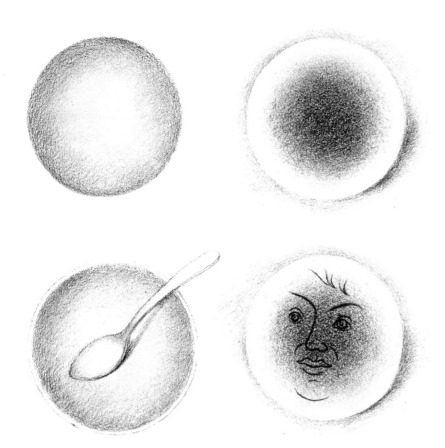

19. Modeling a three-dimensional form by working from light to dark and from dark to light. Spheres (hemispheres) are either bulges or hollows depending on association of ideas — spoon and bowl, face and head.

Seurat's "pointillist" method of painting applied also to his drawing. His modeling technique, with dark projecting and light receding, produces an effect of density and mass.

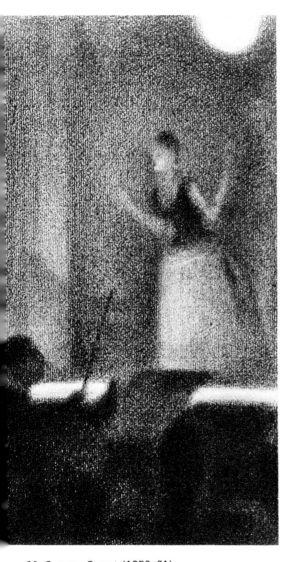

20. Georges Seurat (1859–91)
Café Concert, 12″ × 9 1/4″
black chalk and gouache
Museum of Art,
Rhode Island School of Design,
Providence

21. Auguste Renoir (1841–1919)
Study of a Nude
red chalk
Louvre, Paris

Renoir's customary method of modeling is the opposite of Seurat's. Almost invariably, Renoir's forms are modeled from light to dark, the light projecting and the dark receding.

Texture

An excellent approach to drawing would be to assemble a number of geometric forms—cubes, pyramids, cylinders, spheres, et cetera—paint them white, and draw them. If these simple forms could be covered with various textures such as velvet, satin, fur, or netting, they would provide good objects for the study of texture. Buy a white Styrofoam wig-holder at the ten-cent store—the simpler the form the better. Draw this as you drew the egg or the tennis ball. Buy a cheap wig at the same store, fit it over the plastic form, and add this to your drawing.

In the beginning you will probably try to draw every hair. But look closely at the way a heavily textured form like a head of hair conforms to the underlying form of the cranium. Notice that the strong indications of texture come at the point where your light and shadow meet in your drawing of the hairless head.

When a beginner draws a tree, he is likely, in the same way, to try to draw its every leaf. In time he learns to regard it as a large form or mass and to confine the

22. The most telling evidences of texture are seen at the point where light and shadow meet. Light bleaches out texture to a great degree. and "in the dark all cats are gray." Watch the corner where the form turns out of the light into the dark and note the texture at this point. Do not try to draw every leaf on the tree. Again, put textural indications at the turn of the form.

indications of leafy texture to that same point where light and shadow meet.

Landscape forms are developed in the same way: first, the underlying structure of the earth with its hills and valleys, ridges and hollows; then its covering of grasses and flowers, exactly like the hair which covers the head.

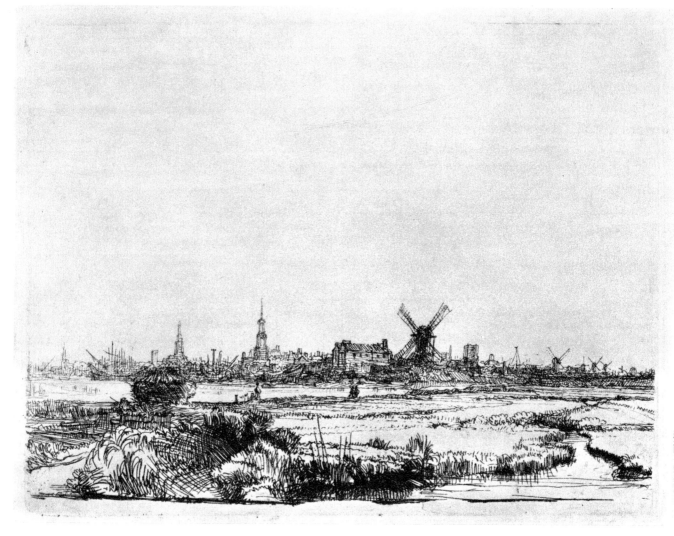

In this typical Dutch landscape, Rembrandt has intersected flat patches of ground with streams and inlets of the sea, with a town in the distance. The horizon line is low, giving the impression of an immense sky. Even in this nearly featureless landscape, the emphasis is placed on the earth shapes and the ground forms. A very slight rise of the ground at the left becomes the dominant form, echoed by a distant windmill. The grasses and weeds clearly grow out of these earth forms, and the notations of these textures are restricted to the edges where horizontal planes come to a corner.

24. Doodlings, preliminary and more
developed. Drawing for its own sake,
without subject. Explore the area of your
paper with pencil or crayon. If the
lines and shapes begin to suggest
recognizable forms, let them do so. Try,
however, to postpone this objective
approach as long as possible, and begin
to be representational or descriptive
only when it becomes inevitable.

4.

Learn to Draw by Drawing

Art is one field in which it is unquestionably true that we learn by doing. As Leonardo said, "The greatest tragedy is when theory outstrips practice." The most foolish thing I ever said to a student was a tired remark I made in response to a question about Picasso. I said, "To me, he is just a glorified doodler!" I apologized the next day and told my class that when an artist stops doodling he is dead and it is Picasso's glory that he doodles on forever.

Drawing is an art, and art is the resolution of conflict and tension, the unification of opposites, the reconciliation of irreconcilables. Man is the social solitary and is hopelessly divided against himself; the division is intolerable to him. Art is the sole means by which he can live with himself. We have a job to do. In practical terms we accomplish this by working in two unrelated fields simultaneously— our work has *form* and it has *content;* it is about itself and it is about something else; it is as *realistic* as possible and as *abstract* as possible. By some mysterious process which is called in poetry *metaphor* and in art *invention,* the artist brings these differences into unity. This fusion is achieved instantaneously by a kind of leap in the dark, a hunch, an intuition. One cannot be taught to take this creative step, but this creative act can only occur within the terms of an art which must be learned and practiced; it is a prize which falls only to those who keep themselves in training.

Start now. Begin at the extremes of Doodling and Rendering and cultivate both as exercises.

Automatic drawing

Take a piece of drawing paper and explore its area with pencil, crayon, or charcoal. Regard your page as a surface and as a space. Draw upon it, reaching for its top, bottom, and sides as if pushing toward its boundaries, feeling over its surface. Let the lines you draw form a record of this feeling, searching, probing of the paper's surface and extent. Vary the quality of the line you are using. If you have been making sweeping curves, shift to angular, sharper lines; if you have been using the point of your pencil or crayon, shift to its side and make broader strokes. Proceed in this way until your page is a maze of scrawls, curves, zigzags, angles, swoops, glides, leaps, and falls. Then, if some form, some object, some thing takes shape as you continue to move over the paper, encourage it, give it definition, bring it forth out of the thicket of lines which you are making. But try to keep the whole area of your page involved and alive, with no dead or neglected areas.

Perform this exercise rapidly. Keep your crayon on the paper all the time and keep moving. Do not try to draw any particular thing—in fact, you should try *not* to. Just draw. If an image emerges, let it do so, and help it along. But don't force it. Your primary aim in this exercise is the exploration of your page with your crayon.

Contour

Now reverse your aim, and instead of drawing *no* thing concentrate on some object with the greatest possible attention. Anything—a chair, a book, a flower. If you can persuade someone to hold quite still for half an hour you have a model. Use a large paper, about $20'' \times 24''$, and a medium pencil or crayon (for example, a BB Wolff pencil) sharpened to a point. Place your pencil on the paper and look at your model or object and tell yourself that your pencil on the paper is your finger touching the contour of the form you are looking at. Start at any point you please. Now follow with your pencil the contour of the form you are "touching," and keep your eyes on the object and not on the paper. Let your pencil move in correspondence with the slow movement of your eyes along the contour until you see the contour turn in and come to an end or until it runs into another contour. When this happens, look at your paper and place your pencil where another contour begins—one which touches the last contour line you have drawn. The more contours you find, the oftener you end one contour and begin another, the greater your chances will be of attaining some degree of proportion in this drawing. But remember that this is an exercise, nothing more. You are deliberately making it impossible for yourself to attain good proportions in this exercise in order to concentrate on the quality of the contour line itself. Draw very slowly. Do not, looking at the object, make a *judgment* about the line—saying to yourself "a curve," "a straight line," "an angle"—but instead feel your way very slowly along the contour. Keep a steady pressure on your pencil; keep the line of even strength throughout; go out and in, making bumps and hollows as you feel the contour swell out or recede. Do not erase; do not go back and repeat a line; keep going on but remember to concentrate upon

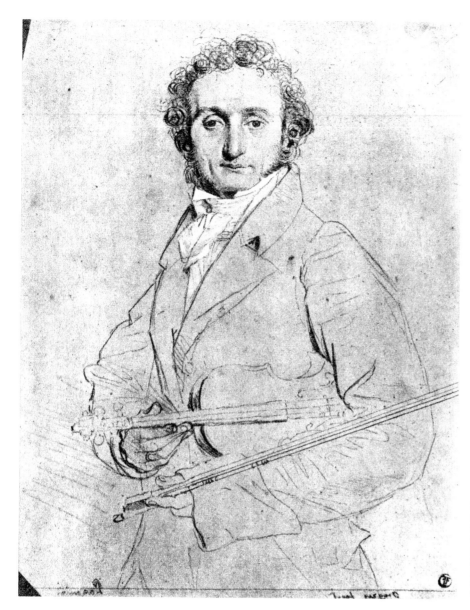

25. J. A. D. Ingres
Nicolò Paganini
counterproof strengthened
with pencil and
white chalk on paper
9 7/16" × 7 1/4"
Metropolitan Museum of Art
Bequest of Grace Rainey Rogers,
1943

In this portrait of the violinist Paganini,
consider the great sensitivity and assurance
of contours or edges of the forms. Looking
at his highly refined drawings, one would
suppose that Ingres drew with slow deliberation,
but it is a matter of record that, on the contrary,
he drew rapidly with great concentration,
tore his sketch from his book, threw it on the
floor, and started again, over and over.

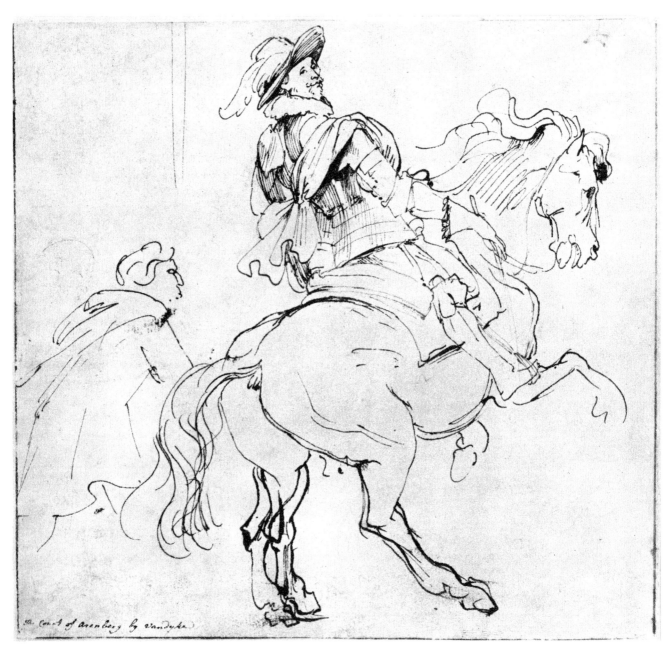

26. Anthony van Dyck
(1599–1641)
*Study of Count Albert
of Arenberg*
pen and ink on paper
Metropolitan Museum of Art
Gift of Harold
K. Hochschild, 1940

This drawing by Van Dyck is an excellent illustration of both contour and action. Rapid as it obviously is in execution, every contour is sensitively felt. Only in the figure who strides along behind the horse are there any diagramatic lines -- the straight lines of the arm and the front lines of the coat.

touching and draw only when you are in touch. What you are after here is a contour line that is sensitive, responsive, nervous. Before you begin to draw in this way, remind yourself of your aim by running your fingertips along the edge of your chair, drawing board, or table. Take notice that if you run your fingers rapidly along such an edge, you will feel a "straight" line, but if you move your fingers very slowly, you will find that this edge is not straight at all but full of bumps, nicks, gaps. Begin to draw and search out these felt variations in your objects' contours.

Repeat this exercise frequently, drawing different objects. When you have made dozens of drawings in this way and have learned to slow down and concentrate upon touching, try drawing in the same way but looking at the paper when you please. This will enable you to get your contours into some proportion. But continue at all times to concentrate upon the principle that your pencil on the paper is your finger touching and passing slowly along the edge of the object.

Note that when a contour turns inside and comes to an end and another emerges behind it, you have established, by overlapping of forms, a sense of three dimensions. A contour drawing is not an outline or silhouette, but more than that.

Make contour drawing a constant practice. It is the essence of all drawing.

Use the first of these exercises as a means of loosening up, or putting your hand and eye into the practice of drawing, and of releasing your imagination. Use the second as a means of developing the habit of real seeing, of concentrating and investigating.

This is a contour
drawing translated
into terms of
relief sculpture.

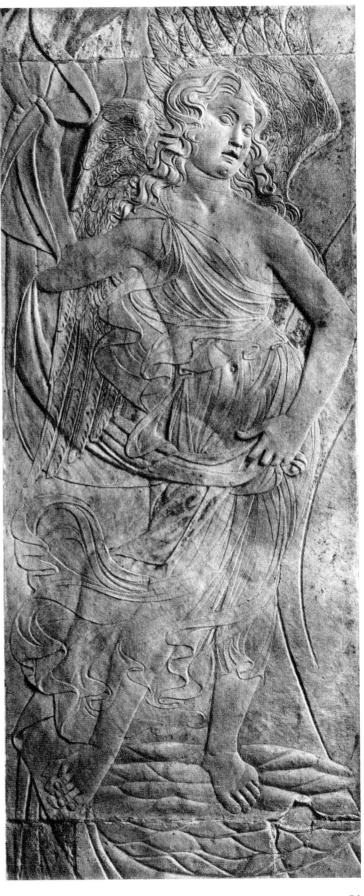

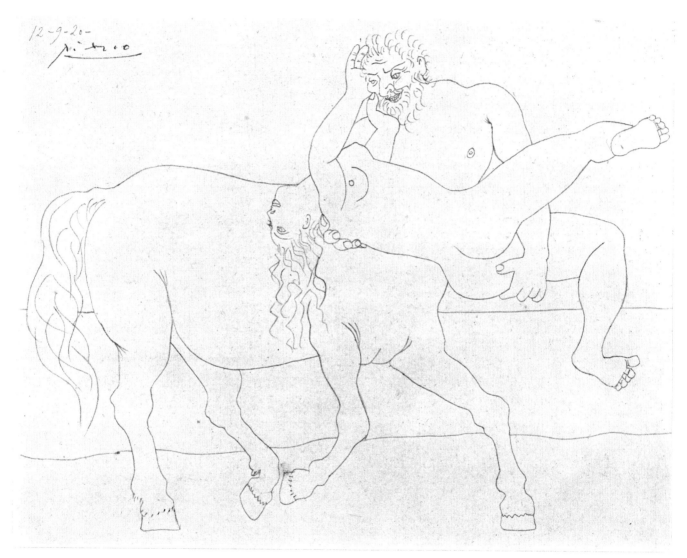

27. Agostino di Duccio
(1418–81 ?)
Angel
bas relief
Rimini Cathedral Chapel
of Sigismondo Malatesta

28. Pablo Picasso (1881–)
Nessus and Dejanira
pencil, 8 1/4" × 10 1/4"
Collection, The Museum of
Modern Art, New York
Acquired through the
Lillie P. Bliss Bequest

Picasso's works in line drawing derive
directly from Ingres, who was, in turn,
inspired by Raphael's line drawings
based on classical antiquity. Do not be
troubled by problems of originality, or be
fearful of being influenced; all great
artists have derived inspiration from
their predecessors.

Action and gesture

Carry a sketch book. Buy a small spiral drawing pad of good paper that will fit into your pocket. Buy an artist's drawing pen, a fountain pen with a flexible nib—one which can be filled with India ink (Higgins or Pelikan India ink, or Higgins Engrossing ink, which is somewhat less black than India ink but flows more freely and is less likely to clog your fountain pen). Make a habit of drawing in your spare time—in the train or on the bus, at the beach or in the restaurant, on the street or in the station. Draw construction workers, shoppers, the people in the audience; take a walk in the park on Sunday and draw trees, rocks, and flowers, the animals in the zoo. Draw the people looking at the animals and the animals looking at the people.

For sketching purposes make a regular practice of another exercise—action drawing, or *gesture* drawing. The best place to practice this is in a drawing class, a "life" class with a model. In the absence of a professional model, ask a friend or relative to pose for you, holding an active pose for one minute or less. Put down this essential action with a quick shorthand notation. Scribble—keep your pencil or pen on the paper and draw rapidly. Move with the movements of the body you are drawing. Think of the whole position or attitude of the model as a gesture, a total gesture. Exaggerate the action rather than minimize it. Your first attempts to capture action and movement will probably be pretty tame and insipid; your figure will be too static.

Learn to estimate the degree to which any object or figure you may be drawing leans away to right or left of the perpendicular, or rises or falls away from the horizontal. Regard the sides of your page as verticals, the top and bottom as horizontals, and relate your oblique lines and directions to these. If the figure bends, bend

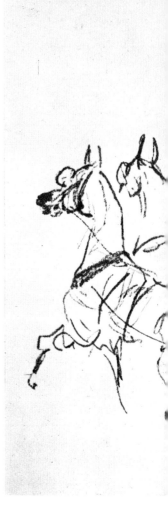

29. Henri de Toulouse-Lautrec
(1864–1901)
Page from his sketch book
Chicago Art Institute

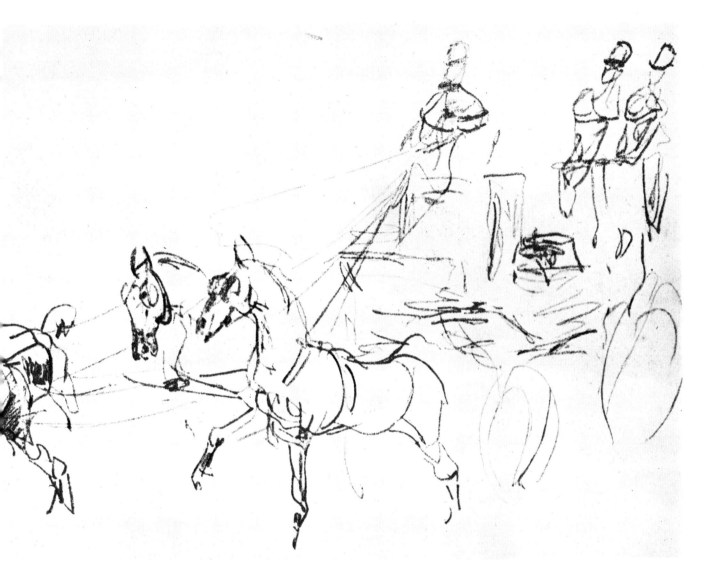

This page from Toulouse-Lautrec's sketch book
was made when he was fifteen years old.
A carriage drawn by four horses, perhaps observed
by Toulouse-Lautrec in the Bois de Boulogne.
Compare these horses in their spirit and animation
with Van Dyck's equestrian drawing (fig. 26).
To capture these fleeting actions, Toulouse-Lautrec
must have watched many horses prancing
past him, capturing details from a number
of animals in succession.

30. Peter Paul Rubens
(1577–1640)
Study for a Kermess
British Museum, London

A pen and ink sketch for
Rubens' large-scale painting
of a "Kermess" or country
dance, now in the Louvre.

A scribbled action drawing of a model undressing in which Rodin must have proceeded almost without lifting his pencil from the paper.

31. Auguste Rodin
(1840–1917)
Figure Disrobing
lead pencil, 12 13/16″ × 7 7/8″
Metropolitan Museum of Art
Kennedy Fund, 1910

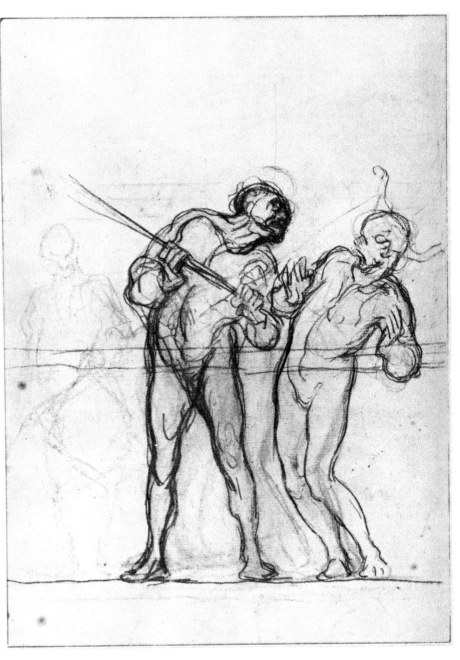

32. Honoré Daumier
(1808–79)
Carnival Drawing

This sketch for a carnival scene,
showing actors on a side-show platform,
is a great example of gesture. The one
figure threatens and bullies; the other,
weak-kneed, recoils in fright.
Right:
All those perfect Madonnas, with
their high polish and refined detail
of form, began like this.

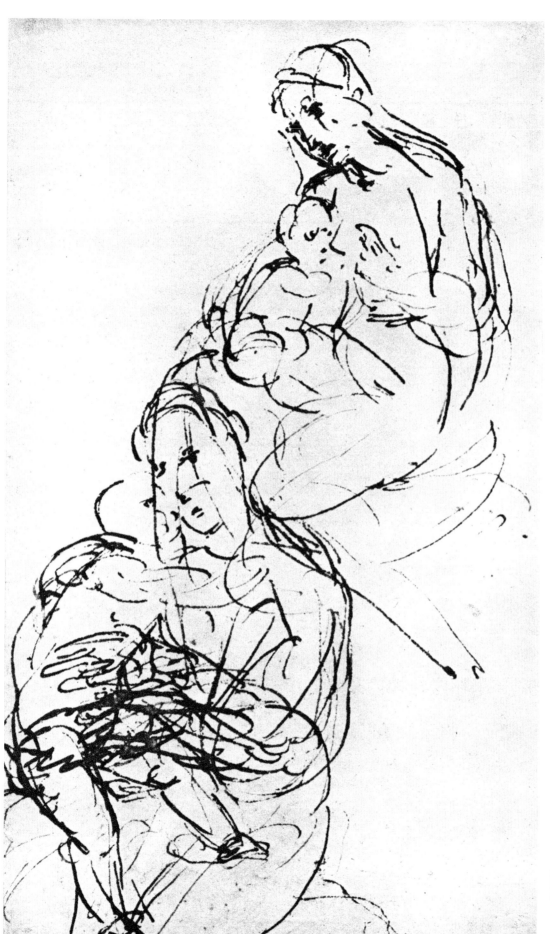

33. Raphael
(1483–1520)
Madonna and Child

35. A. Pollaiuolo
(1431/32–1498)
*Study for Hercules
and the Hydra*
pen, 9 1/4" × 6 1/2"
British Museum, London

A quick idea sketch
in which sculptural
concepts are captured
in a series of shorthand
contours combined
with rapid notations
of modeling and
carving. Compare this
drawing, in its
organization of planes
and volumes, with
a "cubist" work by
Picasso or Braque.

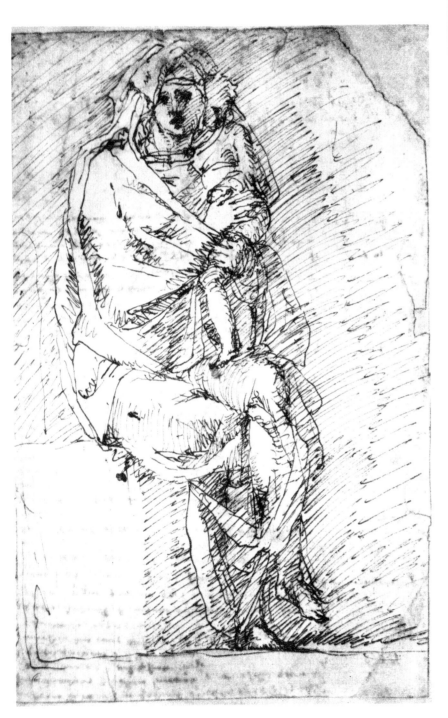

34. Michelangelo
(1475–1564)
Madonna and Child

Consider the swinging movement which characterizes both of these drawings. In the Pollaiuolo, the lion skin which Hercules wears, billows out behind him, as does the fold of the woman's shirt in the Rembrandt sketch; the lion's paw swings between Hercules' legs, as does the pouch on its long cord attached to the woman's waist.

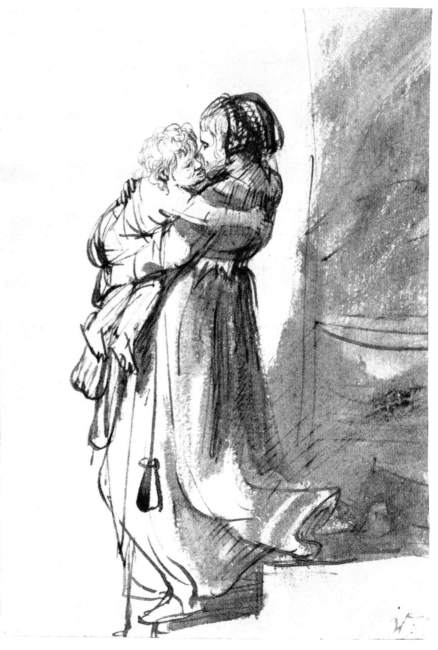

36. Rembrandt van Rijn
*Woman Carrying
a Child Downstairs*
drawing
The Pierpont Morgan Library

with it in a real arc; if the arms stretch out, reach out with them in your drawing; if a leg extends, make your drawing say so. Do not bother with details in a quick-action drawing, but search for the gesture of the whole body. Learn the principle of the *plumb line*—a weight suspended by a string. It will indicate your true vertical. If you hold such a weighted string between your eyes and the figure or object you are drawing, you can gauge deviations from the vertical in the forms you are drawing.

Carry this exercise in quick-action drawing from the life class to the street, the theater, the market, the park, the beach. Make rapid scribbled drawings of figures moving, walking, running, playing. If you attend sports events, draw the contestants. Always try to capture the total gesture. I think it was Goya who said that an artist should be able, in observing a man falling from a window, to catch and hold the attitude of the figure in mid-air. You will discover, if you persist, that when you are drawing people in motion they will usually return to the attitude you wished to draw. If your subject shifts his or her position, draw some other figure until the subject comes back once again to a position close to the original one.

If you find a sketch class with a model, attend it. If none is available, organize one. Form a group of people interested in drawing and let the members take turns posing for each other. Be scrupulous in such a sketch group about *exercises*. Don't spend all your time from the beginning trying to make the perfect finished drawing. Impose strict limitations on yourselves. Draw many one-minute action poses. Make it your aim in these to put down in one minute the information you would need in order to pose the model again in that position— no more. Draw in this way for at least thirty minutes at each session.

37. *Plumb-line:*
a weight suspended
by a cord.

Train your memory by posing your model for half a
minute. Study the pose without drawing. Let the model
rest for one minute while you draw the pose. Then let
the model resume the pose, while you correct your
drawing. Repeat this exercise until you can memorize
a posture or an attitude with some accuracy. In a memory
drawing do not attempt simply to "freeze" the image in
your mind's eye and do not try to simulate the act of
drawing by drawing in the air. Instead, put yourself, in
your mind, in the model's attitude; ask yourself what the
pose *means* (grief, elation, indecision, aspiration, dejec-
tion). Regard the model as a dancer who is expressing
something with the whole body. Expressing what? Draw
that. And describe the pose to yourself in words: "Right
leg forward, left back, left hand on hip, right arm over
head, head tilted back"

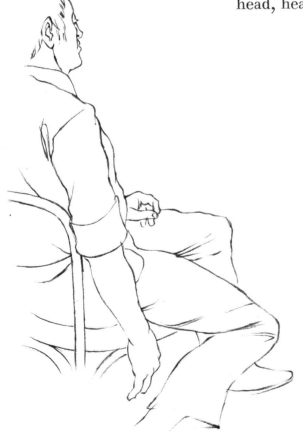

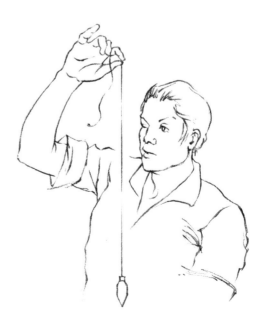

38. A modeled drawing by a student. First, the "ghost" for shape and placement; then its development in three-dimensional form.

Modeling

Pose a model in a simple frontal pose. Have before you a large sheet of bond paper. Break a crayon (conté or Nupastel) in half, and, using the flat side of the crayon, lay down on your paper the shape of the figure in an even, light-gray tone like a "ghost" of the figure. (Take care with the placement of this gray shape on your page. Try to fill the page with the figure. Avoid making a tiny figure on a big page; avoid drawing so large that you run off the page. Try to settle this shape on your page in such a way that the surrounding spaces, as well as the figure itself, are interesting in their design.)

Now continue to draw with the flat side of the crayon, passing back and forth over the surface of the form, pressing harder to make the form go away from you, letting up on the pressure as it comes forward. Work on the principle that light (the whiteness of your paper) comes forward, and dark (the tone made by your crayon) recedes.

Think of the first gray shape you put down as resembling the clay which a sculptor kneads into a form roughly approximating the figure he intends to model. Just as the sculptor will press into this mass with his thumb to turn the form back, to indent it and make it recede, just so will you press with your crayon. Draw over the whole surface of the figure, modeling each form as if in relief sculpture, working always on the arbitrary principle that light comes forward, dark goes away. Continue in this way until the deepest parts, the remotest edges, are quite dark.

Compare what you are doing here with a contour drawing in which you concentrate on "touching" the edges of the forms, and note that in *modeling* you are touching the form in the same way, except that in this case you are feeling over the entire surface and not merely the edges. Practice modeling drapery as well as the figure. Tack up a piece of white muslin so that its folds fall into interesting patterns, and make a modeled drawing of it.

In these exercises in contour drawing and modeling the

A modeled drawing,
executed with crayon,
with the frontal or
projecting forms light,
and all recessions
and indentations
progressively darker,
except for Renoir's
use of dark local
color for the hair
of the girl.

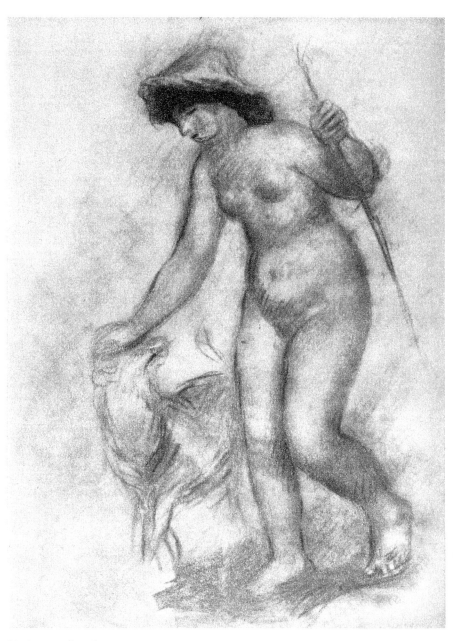

39. Auguste Renoir
Shepherdess
crayon drawing
Collection Durand-Ruel

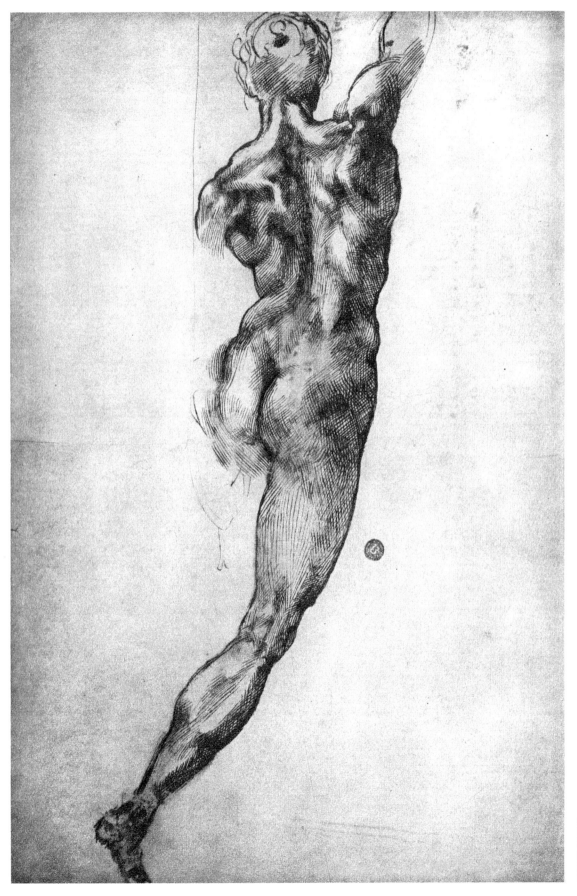

40. Michelangelo
*Study for the
Battle of Cascina*
drawing
Casa Buonarroti,
Florence

Like Renoir's Shepherdess, this drawing is modeled from light to dark, in this case by means of hatching with pen and ink.

aim is the development of greater and greater coordination of your senses of sight and touch.

If you will carry out the exercises with persistence and concentration, you will learn to go beyond the merely visual and to see with feeling—and I don't mean with sentiment but with sensuousness!

Light and shade—the third contour

It would be better to call the following procedure, "Drawing a form which is lighted from the side," but that is awkward, and the expression, *Light* and *shade* (*chiaroscuro* in Italian) is probably here to stay.

In terms of light and shade, modeling from light at the front to dark at the back *represents* an object lighted from the front; modeling from dark at the front to light in the depths *represents* back lighting. There is a third way to model a form, and that is *as if* the object is lighted from one side. It's at this point that confusion develops between genuine modeling and a good-for-nothing imitation of light and shade. It's at this point that a misguided student complains, "I have trouble with shading!" Begin by eliminating this word from your vocabulary. Another great teacher, Kenneth Hayes Miller, used to say, "The discovery of light and shade was the beginning of the downfall of painting."

With contour alone you can make great drawings, as the painters of Greek vases, or Botticelli, or Ingres, prove very well. By modeling simply from light to dark, like Renoir, or from dark to light like Seurat, you can make beautiful drawings. But compared with Michelangelo or Rubens, these great artists are technically almost primitive. Examine the drawings of Rubens and Rembrandt; study their modeling. You will find that they regularly employ a side-lighting which not only gives dramatic relief and projection to single figures but greatly facilitates the massing of many figures in a composition.

Let us make an exercise of this form of modeling in terms of side-light. Place the figure or object which you intend to draw in such a way that the source of light is above, and in front, and somewhat to one side. Try to

arrange the lighting so that two-thirds to three-fourths of the form is in the light.

Make a light contour drawing to place the figure on the page. Then, with a tone, darken the side that is away from the light. Make this simple distinction between the light side and the dark side and keep it simple: a clear, open light which is the white of the paper, and a single dark tone. The important thing is not the precise degree of darkness of this tone, and not any variations within it, but simply that you distinguish between the light side of the form and the dark side. The critical point here is the point where light and dark meet. Note that in a perfect cylinder, this line where light and dark meet parallels the contours of the cylinder. In a hollow cylinder, a similar meeting place of light and dark occurs directly (diametrically) opposite that on the outside. *In effect, you have created a third contour.*

Test this by taking a large cylinder (a big tin can or a mailing tube), painting it white, and setting it up at your eye level, lighting it from above and from one side. Then move around it, keeping your eye on the line where light and dark meet. At one point the cylinder will be half light, half dark; at a forty-five-degree angle from this point it will be all light or all dark. Look at the cylinder's edges when it is all in the light; then move around and watch one of these edges, or contours, move away from the actual edge of the cylinder to a point somewhere between the original contours. You have transposed a contour, as it were.

Take a small statue such as a plaster replica of Michelangelo's *David* and place it on a lazy-Susan, and light it as you lighted the cylinder. Turn it slowly and observe the way light and dark meet and *how* this meeting place changes as the form turns.

Remember that in drawing, contour is almost everything. When you indicate with a line the edge of an object, you are inviting the spectator to touch, to feel over, that boundary or edge. When you draw the contour of the other side of this object, you have enclosed its form. Then,

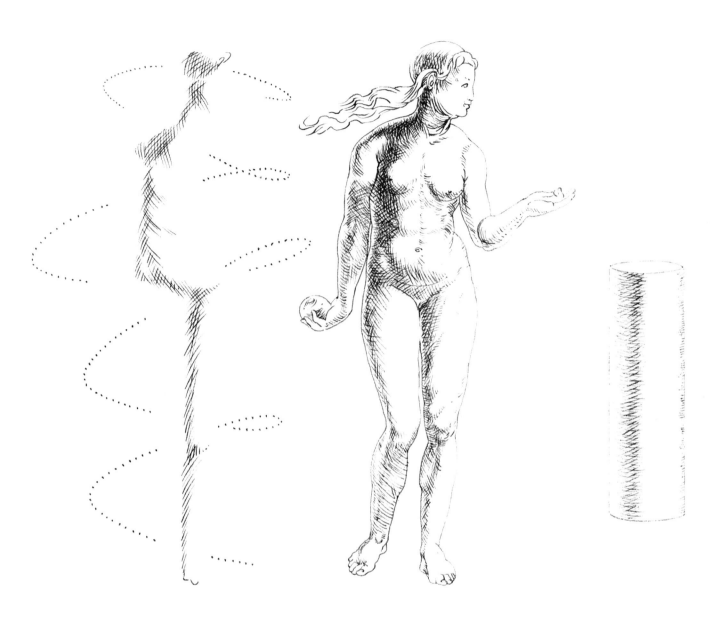

4. Forms drawn in terms of light
from one side. Consider Dürer's Eve as drawn
in this way. In drawing with the light
from one side, find the corner of the
form, the place where light and dark
meet. Try to make this continuous
throughout the figure.

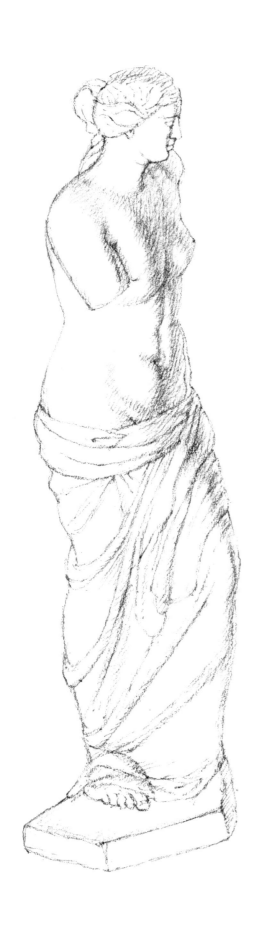

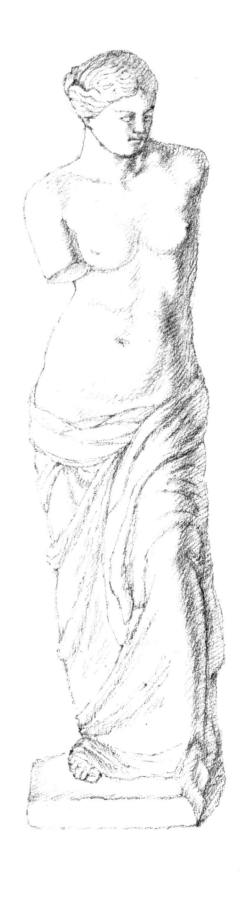

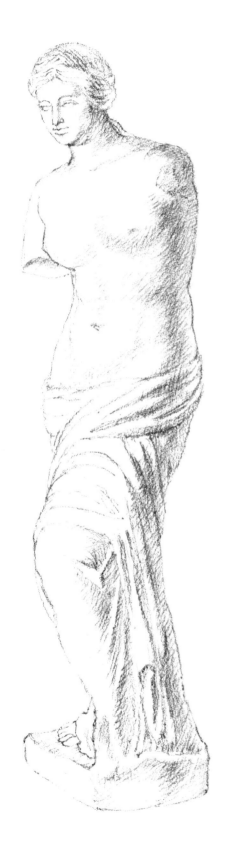

when you darken one side of this form, you have created, where the light and dark sides meet, a third contour—this time on the projecting surface. You are saying to the spectator: "Touch *this* boundary, so. Now feel along the other side—it goes like *this*. And now, at this point, touch the surface here, *between* the outer contours." This third contour puts a corner on the form; it *turns* the form.

With contour alone you can do almost all that any artist can do to "realize" the form of an object. With the third contour you can do everything. As the Bellman says in *The Hunting of the Snark:* "What I tell you three times is true." Beyond this point the law of diminishing returns begins to operate.

In drawing a human figure or any other object, you should proceed exactly as you would do in drawing any simpler form. Draw a bent and battered garbage can or a gunny sack full of potatoes. Here the contours are uneven and full of bumps and hollows, but the whole complex form should be drawn in such a way that it has, where light and dark meet, a principal corner or projection. In drawing the human body, look at the model and draw the body's contours; then darken the dark side uniformly and simply throughout, paying particular attention to that point on the surface where light and dark meet. Regard this corner as the nearest point of projection toward you throughout the figure, a sort of continental divide running through the entire form. Walk around the model and observe the body from a viewpoint where this corner, this meeting point of light and dark, *is* the outer contour and observe its bulges and hollows.

42. A plaster replica of the Venus de Milo drawn in three positions, with the light from the same source for all three.

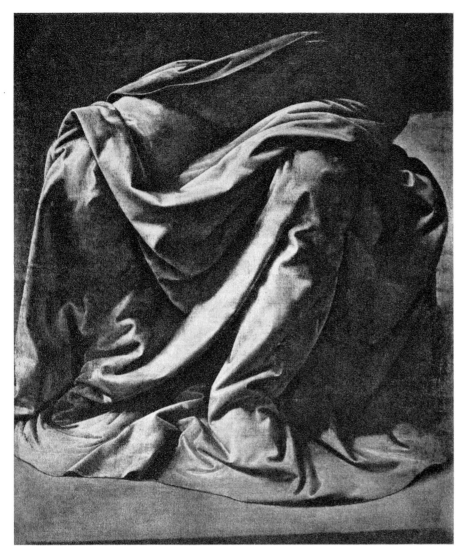

43. Titian
(ca. 1488–1576)
Drapery study
Louvre, Paris

In Titian's day, artists often arranged drapery like this over a "lay figure" or mannikin, first dipping the drapery into a thin solution of plaster of Paris, then arranging its folds before the plaster had set. In this way they could study and draw complicated arrangements of drapery without fear of the subject's becoming disarranged.

Once you have established this corner, this projection, where the total form turns, deal with the incidents within the dark, but keep these subordinate to the main internal contour. Regard the entire light side or plane of the figure as coming toward you from its furthest edge, nearer and near, to that point where light and dark meet and as turning at that point and going steadily away from you. Restrict the smaller minor forms within the light and within the dark to *markings*.

Make a modeled drawing by means of wash (a diluted black or brown watercolor or ink). Begin by placing your figure on the paper with light, tentative contour lines. Then with a wash strike in the dark side of the form boldly and simply. One single tone is essential. You will

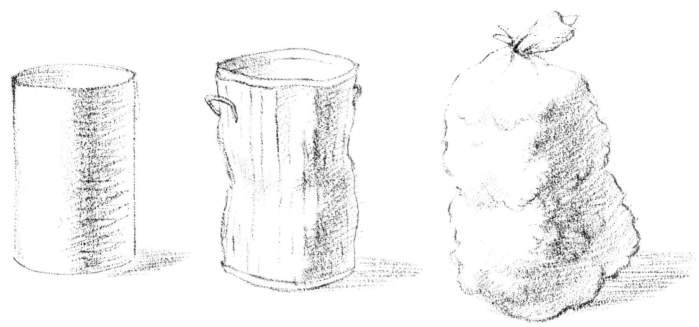

44. A cylinder, garbage can, and sack of potatoes. Note that the figures of Adam and Eve in Dürer's study for his engraving (fig. 16) are modeled in this way.

lose all force and clarity if you go back over this tone very much or if you patch it up. Wash drawing is a good exercise for this reason: you must make this dark pretty quickly throughout and then let it alone. When you apply this wash to the dark side of your figure, you are guided on its outer contour by the contour lines you have already put down. It is the inner edge of this tone, where it meets the light, that is crucial. This edge must follow the undulations of the form. If you apply such a wash to dry paper this edge will be sharp; if you dampen the paper you can make it blur more softly into the white. Study the wash drawings of Tiepolo. He is not one of the profoundest artists, but he handles wash drawing with perfect mastery of his means—a quick, sure delineation of his contours, the form modeled with the bold application of a wash, then the final accents struck in with a darker tone emphasizing the sharper turns of the form where light and dark meet and marking the deep undercuts between forms.

Contour lines followed by a single tone of watercolor or brown ink. A slightly darker wash, a repetition of the first, is applied very sparingly in the few places where forms overlap, as in the shoulder of the nearer figure.

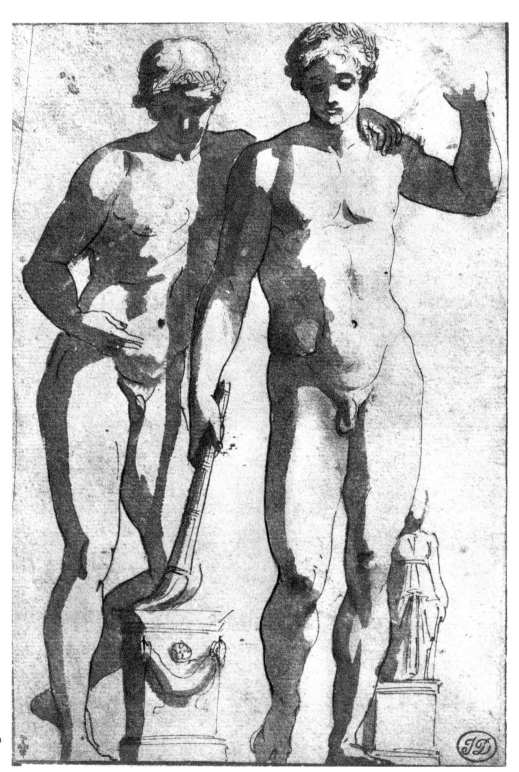

45. Nicolas Poussin
(1594–1665)
wash drawing

As simple in execution as the Poussin composition
of two figures, but with the additional accents
which Tiepolo customarily uses to mark overlappings,
indentations, and recessions.

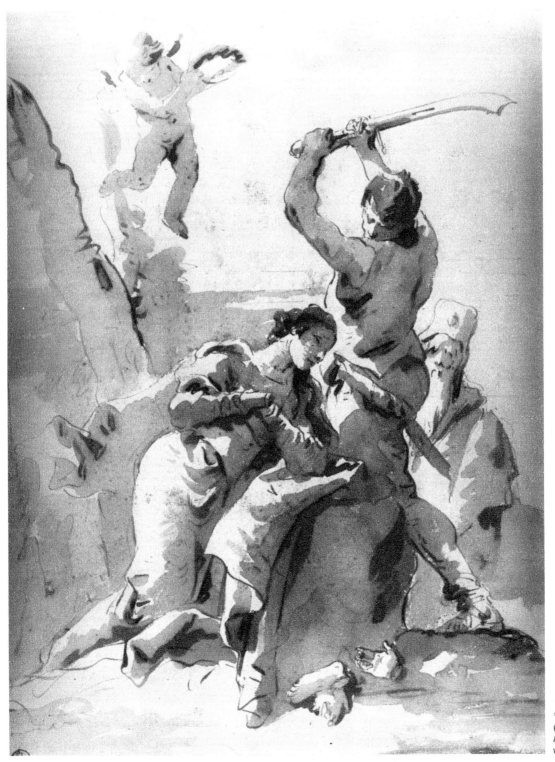

46. Giovanni Battista **Tiepolo**
(1696–1770)
Martyrdom
wash drawing

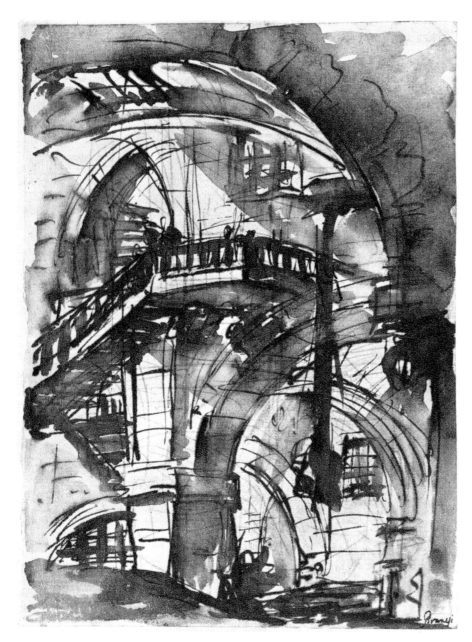

47. Giovanni Battista Piranesi
(1720–78)
Roman Prison
pen-and-ink wash
over pencil drawing
Kunsthalle, Hamburg

A study for Piranesi's famous *carceri* (prisons) engravings. Wash, or tone, used not only for modeling, but for dramatic pattern in the development of a large composition.

When we produce a tone with pencil, charcoal, or crayon, we distribute particles of graphite, carbon, or pigment over the surface of the paper. If we examine a piece of drawing paper under a magnifying glass, we find that its surface is not smooth but rough. This roughness or unevenness is called *tooth*, and papers vary widely in respect to surface texture. Charcoal paper is made with a roughness designed to pick up and hold charcoal particles. Any tone we make by rubbing a crayon on the

paper (any tone except the very blackest) will be a pattern of black dots on a white ground. The harder we press the crayon the darker we make the top points of our rough paper surface and the smaller become the intervening white spaces. The life of a tone, its sparkle and vibration, depends on the fact that the white of the paper is never entirely blacked out.

A tone can be produced with pen and ink by drawing a mesh of lines in any direction. If we do this by hatching and cross-hatching, that is, by a series of lines in one direction, crossed by a series drawn at an angle to the first, we have a greater control over the quality of the tone than when we make smudges with a crayon, because the lines themselves can be given a direction that carries the sense of touch where the artist wishes to send it. The lines can be curved in conformity with curved surfaces like those of the human body. And the spaces between the hatched lines, the little diamonds or lozenges of white paper, have shape and direction too.

Study a drawing by Michelangelo, a figure drawing made with a pen. Find as good a print of such a drawing as you can and make a free sketch from it. Observe its contour lines, the way in which the forms are turned by means of tones created by hatching. Watch the way in which a contour turns inward and becomes a tone and again how interior tones which model the forms of muscles narrow down and become sharp contour lines.

Compare such a drawing by Michelangelo with one of his sculptures. Notice how his pen lines and the marks of his chisel correspond. He draws on his block of marble with the chisel; he carves out his form with pen on paper in exactly the same way. He says in a letter: "By sculpture I understand an art which operates by taking away

In this figure drawing by Michelangelo, executed with a reed pen, note the "hatching" and "cross-hatching" as described in the text. These hatched lines follow the direction in which the form turns. Consider the interstices between these cross-hatchings and see how the white of the paper sparkles through them. Michelangelo has emphasized the dark that runs from the figure's right foot diagonally upward to the left shoulder, thus giving unity and continuity to the forms of the body and causing this multiplicity of bumps and hollows to add up to a single coherent figure.

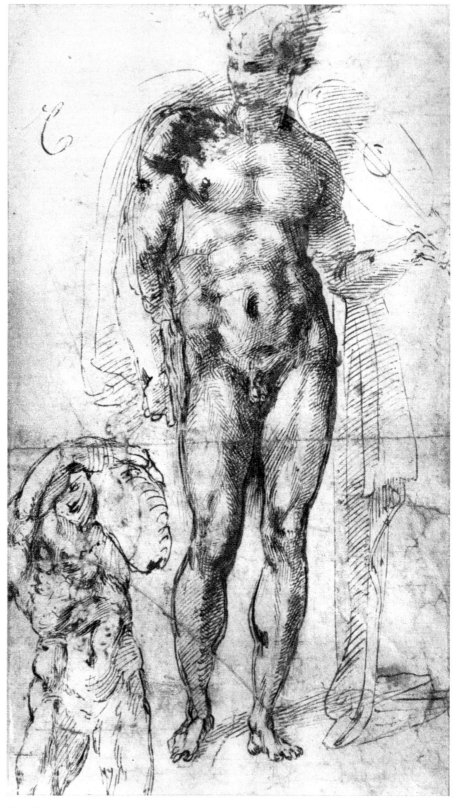

48. Michelangelo
Male Nude
pen drawing
Louvre, Paris

49. Michelangelo
St. Matthew
marble, 8' × 10'
Academy, Florence
Above right: detail

Compare this carving by
Michelangelo of the figure
of St. Matthew with his
drawing of the male nude.
Notice how the marks
of the chisel closely
resemble his pen lines,
giving the effect of
"cross-hatching" even
to his sculpture.
In the detail above,
the marks of the chisel
are clearly apparent in
the face of St. Matthew.

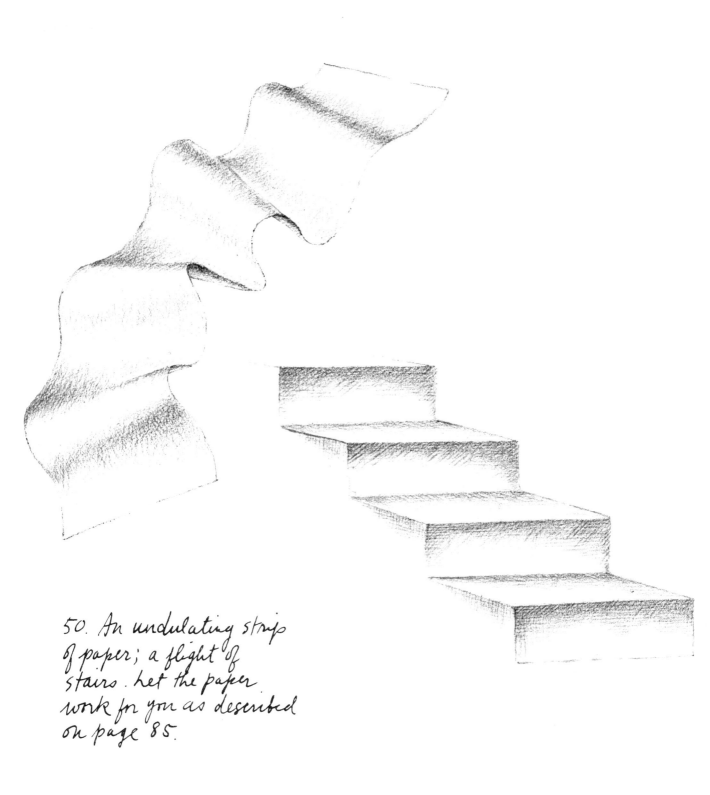

50. An undulating strip
of paper; a flight of
stairs. Let the paper
work for you as described
on page 85.

superfluous material...." And in a sonnet he writes: "Even the greatest artist has no concept which is not encompassed within a single block of marble." He might have said the same thing about a sheet of paper. In every great drawing it is the paper which comes to life exactly as stone becomes form in the hands of a carver. A beginner thinks of his paper as nothing and the marks he makes upon it as everything. But as he learns his craft, an artist discovers that in an important sense the opposite is the case. He, too, "operates by taking away"—he reduces the light of the paper, he creates upon its surface undulations, bumps, and hollows, indications of boundaries and edges, and at all times it is the paper surface which is positive and his lines and tones which are negative.

Take a wide strip of white paper and tack it to your drawing board so that it ripples in and out in a series of even bumps and hollows. Draw this waving surface. Note that you need only draw the turn of the form with a tone at each bend, forward and backward. If you will turn the corner with a tone the paper will do the rest—it will go in the direction you send it until you give another signal for a change of direction with another tone. Draw a stairway, a series of horizontal and vertical planes, in the same way. The paper will make both planes for you—all you need to do is turn the corner from vertical to horizontal to vertical.

Regard the light surface of your paper as positive (and note that it isn't truly white—you can prove this by putting something whiter against it) and the darks made by your pencil or pen, crayon, or wash as negative. The light is the active principle and dark is merely its absence. (Those are relative terms—we cannot even imagine absolute white or absolute black.) By means of your black-on-white drawing you are controlling the light,

directing it. In a good drawing the light falls upon an object, strikes it, and flows over it; it jumps and skips and lands again; it broadens and narrows. The dark is its interruption, its barrier, its obstacle. The dark will seem active but it is in reality reactive. Regard the light as resembling a stream moving over uneven terrain. It broadens out slowly where it meets with little resistance and then flows swiftly between narrowing boundaries. If we look at rocks projecting above a swiftly flowing stream, the rocks will appear to be moving upstream against the current. In the same way your darks will appear to move against the light, but it is the light that must do the work.

A good drawing is an economical drawing. In the beginning we draw too much when we draw; we work too hard; we torment the paper when we should be letting it alone. Eventually we learn to let the paper itself do the work, as it were. We discover that we need only inflect the paper and it will carry the form from one inflection to another without being touched at all. A great drawing has an awe-inspiring look of effortlessness. When the contours are right—when they are sensitive, nervous, descriptive—and when the turns of the form truly carry the form across from one contour to another, then the paper becomes the very substance of what is represented: flesh, bone, muscle, cloth, wood, stone, or metal. Even the most sophisticated observer will find such a drawing mysteriously beautiful because he will find himself looking at the paper where no work at all has been done, and not at the artist's lines and tones and markings. At this point the artist has become a sort of conjurer, an orchestra conductor. The paper on which he draws is doing his bidding; he directs it this way and that and it responds to his touch, becoming the forms he wishes to create.

A beginner is usually severely handicapped by the fact that he has many preconceptions. He has seen innumerable pictures, and he tries—in vain—to imitate them. He tries to make a "perfect" drawing every time and is discouraged by his inevitable failure. In your exercises, try for one thing at a time and limit your aim to that. In a warming-up, "doodling," automatic sort of drawing, make the exploration and division of the area of your paper your one concern. In a quick-action drawing, limit the time you spend on it and *scribble* for the total gesture, eliminating details. In contour drawing, limit yourself strictly to a single, firm contour line, drawing only when you are concentrating on the idea that your pencil or pen on the paper is your finger touching the edge of the form. In modeling, hold to the principle that your crayon moving over the surface of the paper is your hand passing over the form of your object. When you tackle the problems of light and shade, limit the time you spend in this pursuit and return to these simpler exercises again and again.

5.

Inks, Crayons, and Drawing on Colored Papers

In the catalogue of an exhibition of "Master Drawings," I note the following indications of technique, among others: pen and ink, tinted paper; pen and bistre wash; drawing with gouache; silver point heightened with white on tinted paper; pen and bistre heightened with white on blue paper; black and red crayon; pencil and sanguine; red, black, and white chalk, et cetera.

To translate a little:
Bistre (no longer manufactured) was a brown color prepared from wood soot by extraction with water. Its color came from incompletely burned wood and was subject to fading. *Sepia*, another brown pigment, originally prepared from the ink of the cuttlefish, was likewise impermanent. These colors are now superseded by the umbers—raw umber and burnt umber. In practice you will find that watercolors make better tones for wash-drawing than diluted inks will provide. Ink, either brown or black, is liable to become grainy or to have an unpleasantly viscous quality. Use brown ink full strength with a pen, and make brown washes with umber water-colors.

51. Leonardo da Vinci
(1452–1519)
*Study of Drapery
on Red Paper*
silverpoint, brush in white,
white relief,
black shading on
red tinted paper
Gabinetto Nazionale delle
Stampe, Rome

This drawing on red-toned paper was begun with silverpoint and continued with a darker crayon. Then the lights were brought up by the application of Chinese white with a watercolor brush. The figure is a preliminary study of a Madonna for a painting of the Annunciation.

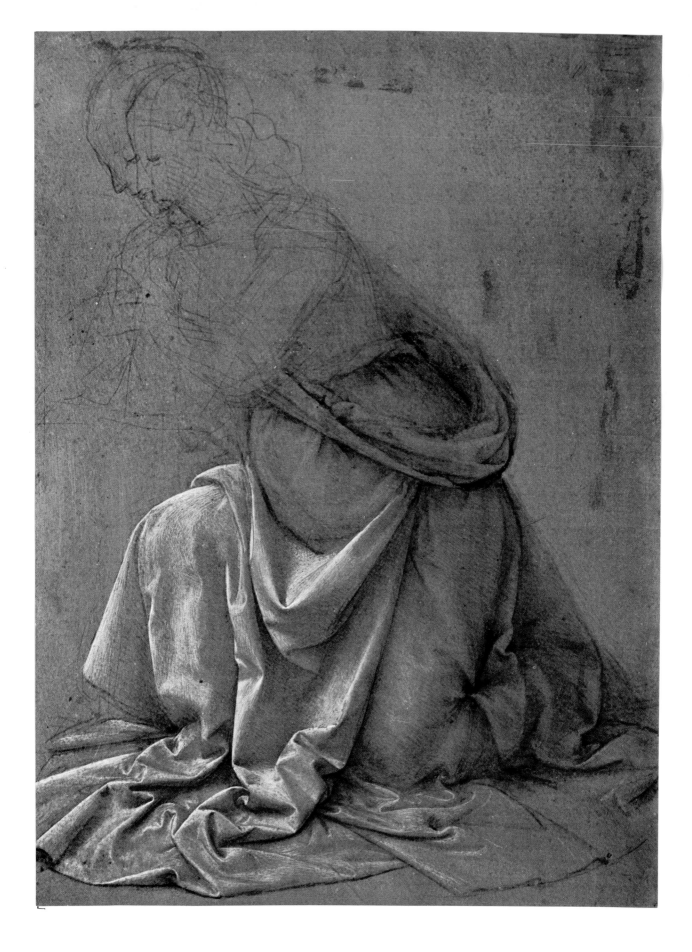

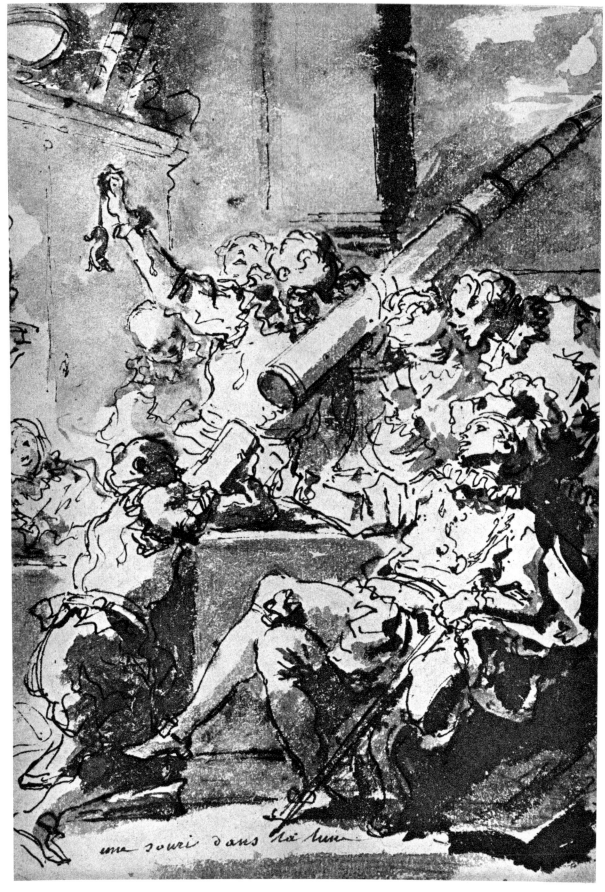

une souri dans la lune

88

52. Jean Honoré Fragonard
(1732–1806)
The Mouse in the Moon
wash drawing

Inks, Crayons, and Drawing
on Colored Papers

Gouache is opaque or "impasto" watercolor. In general,
watercolor is a transparent medium. The white of the
paper reflects through the color. However, pigments vary
in the degree of their transparency or opacity. Some, like
alizarin crimson, ultramarine blue, and viridian green, are
very transparent; others, like the "Mars" colors (synthetic
iron oxides), oxide of chromium green, and Indian red,
are very opaque. The addition of white (titanium white
or Chinese white) will make any watercolor pigment
more or less opaque. Casein colors provide an ideal
gouache medium. In casein the binding medium is
manufactured from skim milk; in watercolor the medium
is a gum, usually gum arabic.

Gouache lacks the brilliance of watercolor but has a kind
of pastel quality which has its own value. Gouache is an
easier medium to handle, because its opacity means that
mistakes can be painted over and changes can be made.
Watercolor must be handled with greater dexterity,
because it cannot be overpainted very much without
losing its color and freshness.

*A drawing in bistre.
Today we obtain
warm colors like this
with sepia or umber
watercolor.*

Chalks in any color are pastels, made by grinding dry pigments in a solution of gum arabic or other binding medium and shaping into crayons. (The white pigment used is usually precipitated chalk, and this word has become associated with all crayons and pastels.) Today's Nupastels (Faber) are excellent drawing crayons or "chalks," as are conté crayons and pencils.

A beginner would be well advised to limit his range of pigments in using watercolors and pastels. He should work for a long time with a few colors, a "limited palette," before venturing into an extended color range. Nearly every essential tone and color can be produced by the use of black and white, brown (the umbers), red (Venetian red or sanguine), and yellow ochre.

Sanguine is a red, terra-cotta-colored chalk.

Silver point is a stylus made from sterling-silver wire. These wires of solid silver are obtainable from hobby shops and the stores which supply jewelry makers. A useful silver point can be prepared by inserting a length of wire into a holder designed for leads. Or an ordinary lead pencil can be split in half lengthwise, the lead removed, and a silver wire of the same diameter put in its place, after which the pencil can be glued together again. The point can be kept sharpened with a sandpaper pad. (A smooth rounded point is important. A very sharp point will cut your paper.)

Paper must be specially prepared to receive silver point. It must be covered with a chalk or gesso ground. A simple and easy way to do this is to cover illustration board with a smooth coat of casein paint. (Do this quickly with a broad brush. Avoid excessive brushing, so that the paper is not too much soaked with water.) When this has dried thoroughly (preferably overnight), you can draw on it

with silver point. The grains of pigment in the surface coating of the paper will be abrasive enough to retain particles of silver from the point. The line made with silver point is gray—never black—but it has a delicate silvery quality, and when in time the silver tarnishes the quality of the line may be improved. Silver point cannot be erased—a mark made with it is there to stay.

Interesting results can be obtained by tinting the gesso or casein ground gray, pink, blue, et cetera.

To draw with colored chalks and crayons on tinted paper, use toned charcoal papers.

6.

Texture
and Color
in Drawing

Make a practice of drawing simple, basic forms like cubes, cylinders, pyramids, and spheres. When you can model spheres and egg-shaped forms adequately, assemble a group of round-shaped vegetables of varying textures and colors and draw these. Begin by drawing their forms in the simplest possible way without regard for texture or color, then proceed to indicate their textural differences. Note that both texture and color are most clearly distinguishable at that point on the form where light and dark meet. In shadow very little color or texture are discernible—all forms recede into a common dark. Similarly, the light is uniform and unvarying on all these varicolored objects. The color and the texture appear between the lightest light and the dark.

Study the forms in landscape. Look at the masses of foliage in trees. Study the form of a grassy hill. A beginner is inclined to draw every leaf on the tree and every blade of grass. If you look at the tree as a whole you will see that it is composed of a few large masses or forms. The leafy texture of the whole mass is most clearly discernible at that crucial point where light and shadow meet, and the most intense color occurs at the same point. Look at earth forms in the same way and once again let the paper work for you. Be economical. Make the salient indications of color and texture at those points where they count.

Drawing is capable of indicating an almost infinite range of textural variations—smooth, rough, shaggy, wrinkled, sharp, blunt, wet, et cetera—but its capacity for color is limited. However, a considerable color variation is obtainable within the context of a drawing. We are largely dependent here on the association of ideas. For example, among tree forms, light masses of foliage will

suggest light greens, and dark heavily textured areas will suggest dark greens. A darkly modeled cheek, chin, or end of nose will suggest ruddiness.

So far we have been concerned with the fundamental black and white, or light and dark, aspects of drawing. However, the line between drawing and painting is not clear cut if, indeed, there is any meaningful distinction at all. There are great draftsmen who can paint with black and white. Goya said to a friend: "In nature there is neither color nor line, only sun and shade. Give me a piece of charcoal and I will produce a most beautiful picture for you." And there are great painters whose work is almost all drawing. The greatest colorists employ an extremely limited palette. I once examined a dazzling painting by Rubens, a *Perseus and Andromeda* in the Berlin Gallery, to determine, if I could, what colors had been employed to produce so much brilliance and contrast, and I could count only six pigments: black, white, ochre, umber, one blue, and one red.

If we add one other contrast, that of warm and cool, to our contrast between light and dark, we can make drawing yield almost everything that painting affords, and Rubens achieves this with red, black, and white chalk on tinted paper of varying shades of tan, ranging from yellow to light brown. This is a method of drawing which requires control and economy.

Practice this way of drawing by beginning with drawings in red chalk (sanguine) on manila paper. Bear in mind that your paper is not white, that it already has a color slightly darker than white. In this case, you are beginning with a tone provided by your paper. Sketch in your contours very lightly and keep your modeling tones very light in the beginning. Draw a portrait head or a nude

In drawings like this, Rubens achieved
a full range of his painting medium by
means of three single crayons or chalks —
black, red, and white — on white paper.
His preliminary contours are established with
red chalk (sanguine) and serve to provide
a warm flesh color which he emphasized
around the eyes, nostrils, lips, and cheeks,
those points where blood comes nearest the
surface. His darks are then intensified with
black crayon, and this, like the red, is used
not only for modeling, but also for color —
black hair, black collar and black for the
pupils of the eyes. Finally, the black crayon
serves to reinforce the points along the sides
of the head and on the neck where the light
turns into shadows, thus producing a cooler
color inflection or "half-tone." The principle
here is to convey that special color of flesh, the
nuances of warm and cool color simultaneously
like a pearl. This quality results from the
transparency of skin and of the thin layers which
make up a pearl. Light is reflected to our eyes
from such substances after it has penetrated to
a slight degree beneath the surface. The painting
of Isabella Brandt, Ruben's first wife, based
on this drawing, is in the Uffizi in Florence.

53. Peter Paul Rubens
Portrait of Isabella Brandt
black and red chalk,
heightened with white
and reinforced with
pen and brush
British Museum, London

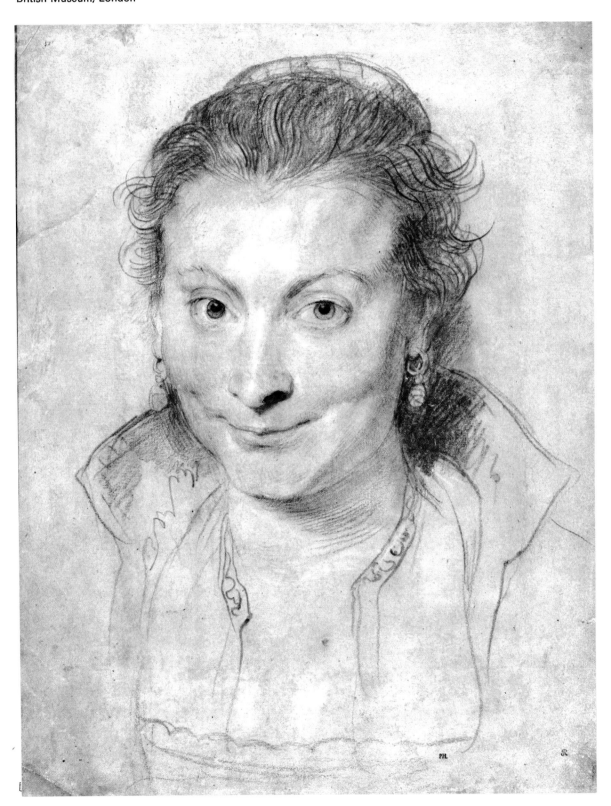

figure in this way and regard your red crayon as providing not only your darks, your shadows, but also the warm local flesh color of your face or figure. Do not work much in the light areas with red—let the yellowish tone of the paper carry these. Then take a white chalk and bring the lights up from the yellow half-tone just as you have been working down from it with the red. Make many drawings in this way until you can achieve a balance between your dark (red sanguine) and your white. When you draw on a toned ground like this with dark and light crayons, the color of the paper provides great leverage. The paper itself is the fulcrum of your lever.

We have already pointed out that in drawing with a black medium on white paper it is the point where light and dark meet that is critical. It is at this point that your dark needs emphasis. When we emphasize this turn of the form by making it a little darker and richer than the prevailing dark tone, we emphasize the contrast between light and dark where they meet. In this way the white of the paper looks even whiter as it approaches this turn than it looks on the contour on the light side. When we draw on a tinted ground and develop our lights with a white chalk, we must treat the light in the same way we have previously treated the dark—it becomes lighter as it approaches the turn of the form. The highlight pushes toward this corner and the dark presses back, as it were, to meet it.

When you have learned to draw on a yellowish or buff paper in this way with sanguine and white chalk, always striving to make the paper do all the work for you that it can, take a good look at the model you are working from. Notice that the yellow and red tones you have been using approximate the local color of the flesh of the model but that the turn of the form, the corner where light and

dark meet, is cooler and grayer—and darker—than the warm colors of your drawing. Proceed to use a black chalk or crayon to produce this cooler half-tone, and intensify also the dark markings where forms overlap in the dark with the same black. In black and white or light and dark drawings, we can turn the form through a progression from light through dark half-tone to reflected light-to-dark markings—four stages. When we draw with black, red, and white on a warm ground we add to this series of lights and darks another series, that of warm and cool colors. The form turns from cooler light (white chalk) through warm local color (the color of the paper, reinforced by red chalk) through a cooler half-tone (the gray produced by black crayon) through warm reflected light (sanguine over a warm ground) to a cooler dark (the dark markings should be warm in themselves, but the addition of black to sanguine will make them cooler than the reflected light). We have extended our range very greatly.

7.

Fore-shortening and Perspective

Foreshortening is the procedure by means of which a form is represented as extending toward the spectator or away from him. Perspective is a system for representing three-dimensional objects in spatial recession from a single point of view.

The essence of foreshortening is overlapping. To put one form in front of another, it is enough to show that its contours overlap those of the form behind it. In fore-shortening, the progression into depth is made in steps—from *this* form in front, to *that* one behind it, to another behind that, and so on. Perspective gets its results mostly by a diminishing of size as forms recede into the distance.

Draw a series of rocks of various sizes stretched out in a line. Draw a human leg in profile from hip to knee. Now assume that we have walked to one end of our line of rocks and are viewing them end-on. And look at the leg we have drawn with the knee pointed toward us.

Perspective assumes a fixed point of view. The horizon is at the spectator's eye level and all parallel lines are treated as if they met at that point to which he directs his glance. It assumes a profoundly egocentric view of the universe. The Egyptians were innocent of it, as were the ancient Greeks and the Chinese. It was developed in Europe during the Renaissance, and the self-centered philosophy which produced it flourished for about four hundred years. From an artist's point of view it represents an attitude toward the world which was born with the invention of perspective and died (a slow death) with the invention of the camera. I believe it can be shown that artists were never wholeheartedly committed to it.

Perspective has its usefulness, and an art student does well to know something about it just as he would be well-advised to study anatomy. But this is the place to warn him against the fallacy that he should first learn all there is to know about these branches of knowledge and *then* begin to draw and paint. This is putting the cart before the horse. He must draw and paint first and draw and paint all the time and learn what he needs to know of anatomy and perspective as the needs arise (and they may never in the individual case have any importance at all).

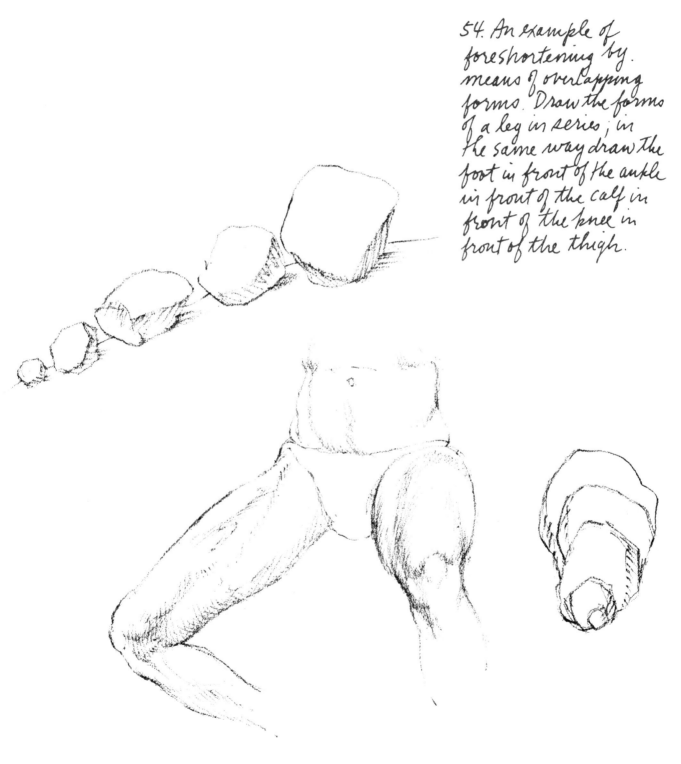

54. An example of foreshortening by means of overlapping forms. Draw the forms of a leg in series; in the same way draw the foot in front of the ankle in front of the calf in front of the knee in front of the thigh.

This is a wood engraving of an artist drawing a foreshortened figure by means of a grid.

Essentially, a perspective drawing is one which we would make if we drew on a vertical plane of glass, a window pane, situated between ourselves and the object or view which we wish to depict. However, to do this directly would present some serious difficulties. To understand this, let us consider Albrecht Dürer's drawing of an artist sketching a reclining figure. Note that the artist has removed himself to a considerable distance from his model. If he approached so closely that he could draw upon the plane which is set up in front of the model, he would find that the parts of the model's body which are close to the plane would be monstrously large compared to the more distant parts. In this case, the knees would be disproportionately large in relation to the head.

Dürer has overcome this difficulty by withdrawing to a distance from his subject, leaving the transparent plane close to his model. This plane is now too far away to permit him to draw upon it directly. He has substituted for a glass pane a frame which he has divided into squares by means of threads, and he draws upon a paper squared off in the same proportions. In order to steady his line of sight, he has placed a stylus before him as a point which

he can keep fixed at the same spot on his subject. Now all he needs to do is transcribe what he sees through the frame to his paper, square by square. The resulting drawing will be "in perspective."

The artists and architects of the Renaissance developed the rules of perspective whereby a complex composition, such as a crowd of figures in an elaborate architectural setting, could be organized in terms of a single point of view, as if the elements in the picture had been posed and then drawn by means of Dürer's squared frame.

The drawing on the window pane shows us that parallel lines converge as they recede into depth, that objects of the same size appear smaller in proportion to their distance from the observer, and the rules of perspective enable us to determine the *rate* at which these parallel lines converge and the *degree* of diminution in apparent size of the distant objects.

Experiment with the rules of perspective by drawing a number of boxes in a random arrangement, "freehand." Then draw a box in "one-point perspective" and another in "two-point perspective." Note that in one-point perspective the front plane of your box is parallel to the horizon (and parallel to the window pane or "picture plane"), while its sides recede toward a single point on the horizon; in two-point perspective each side of the box recedes toward its own vanishing point.

Draw boxes as if seen below your eye level, at your eye level, and above your eye level. In the illustration, all the boxes are drawn with their bottoms and tops parallel to the ground. As a result of this, all their sides recede toward vanishing points on the same horizon line. (Bear in mind always that the horizon is at the observer's eye level.)

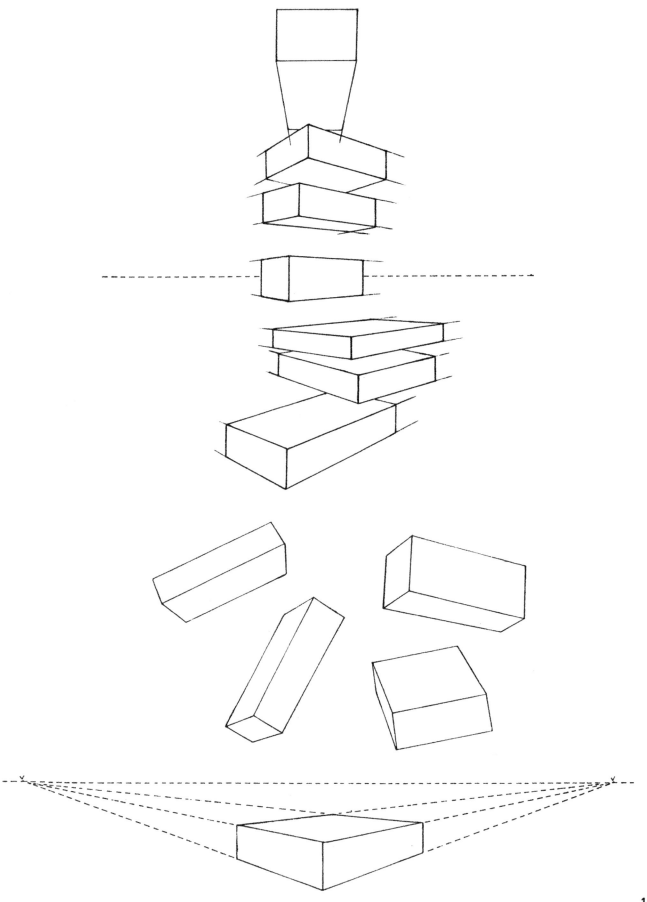

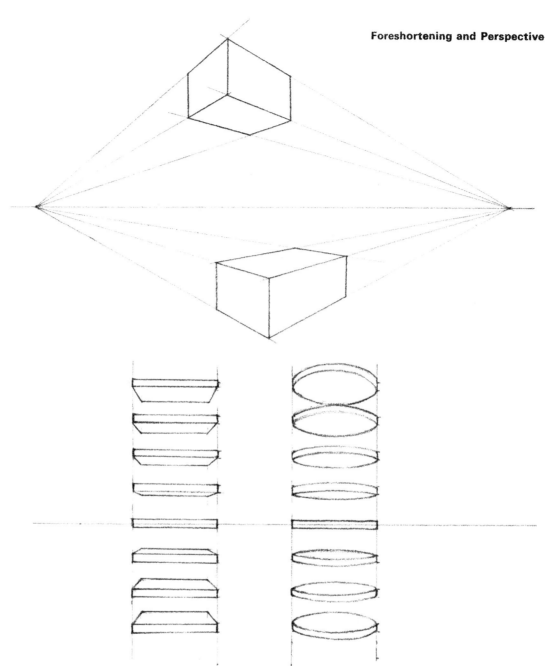

Opposite:
56. Boxes in perspective
Above:
57. Boxes and discs,
above and below
the horizon line.

Consider the perspective factor in the paintings by Giotto, Piero della Francesca, and Van Gogh which are reproduced here. Giotto painted before the introduction of "scientific perspective"; Piero, a friend of the architect Alberti, exemplifies the Renaissance preoccupation with perspective; Van Gogh may be taken as an example of post-perspective drawing.

Giotto and Van Gogh scramble their perspective. Giotto's temple is a token temple. It makes no pretense at realism. In the Giotto, the figures are the important element; the architecture is a mere scaffolding or platform to support them. In the Piero, we have another stage set, but one in which the architectural environment will compete on a basis of equality with any cast of characters which may come on stage. In the Van Gogh, the buildings themselves become the actors and the distortions in their perspective are the lineaments of their character and personality.

İ hope the reader will regard these paintings as the works of master artists of equal stature and will study their use of perspective in each case as deliberate and effective artistry.

I have already urged you not to draw in terms of light and shade but in terms of *modeling*—which is to say, in terms of touching and grasping. For this reason, cast shadows should generally be avoided like the plague, because shadows are not *things*. And yet, cast shadows have their importance. Dante says in his *Inferno* that at one point in hell he could not distinguish between the living and the dead until he noticed that the spirits of the dead *cast no shadows*. And similarly I'm inclined to minimize the importance of perspective, and yet we have been conditioned through several centuries to see within terms of this convention. Recently the mystery of the

Giotto's great narrative power and innovative natural portrayal of people was a marked departure from the Byzantine style of two-dimensional depiction. Although there is no attempt at "scientific" accuracy, the suggestions of perspective, with space defined by gestures and postures, marked the beginning of three-dimensional form and space on a plane surface, and secured Giotto's position as one of the greatest figures in the annals of Italian painting.

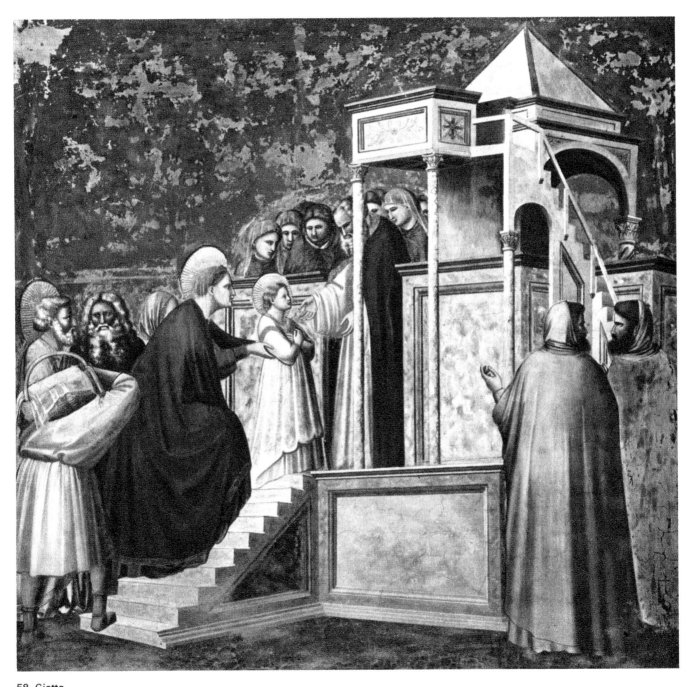

58. Giotto
(1267?–1336/37)
*Presentation of the Virgin
in the Temple*
fresco
The Scrovegni Chapel, Padua

59. Piero della Francesca
(1420–92)
Architectural Study
Galleria Nazionale delle
Marche, Urbino

Painter and mathematician, Piero was
one of the earliest developers of the principle
of scientific perspective and author
of a treatise on the subject. He was a
close friend of the architect Alberti, whose
architecture this painting closely
resembles. As opposed to Giotto's style,
where the spectator's position is not
fixed but shifting, Piero's painting
assumes a single point of view.

greater size of the rising moon in comparison with its apparent size at the zenith was explained as an effect of perspective. When we look toward the horizon we note that objects diminish in size in proportion to their distance. Hence we feel that anything as big as the moon appears to be, when we see it beyond the horizon, must be very enormous indeed, whereas we have no intervening and diminishing objects between ourselves and the moon when it is high in the sky and hence no impression of great size. In other words, the diminishing size of receding objects is directly perceived and affects our judgment.

It is enough where perspective is concerned to be *plausible*, and the greatest artists from the Renaissance to the present day have been no more than that. Perspective will not serve as a means of organizing forms in art; it does not afford a principle of composition. Those artists who represent great spatial depth in their work do so by moving abruptly and at one step from the forms in the front plane to those in the background, eliminating the

In this drawing we have a modern rejection of the strict perspective of the Renaissance and a revival of Giotto's looser, freer form.

60. Vincent van Gogh
(1853–90)
Street in Saintes Maries
brush, reed pen and ink
Collection, The Museum of Modern Art, New York
Abby Aldrich Rockefeller Bequest

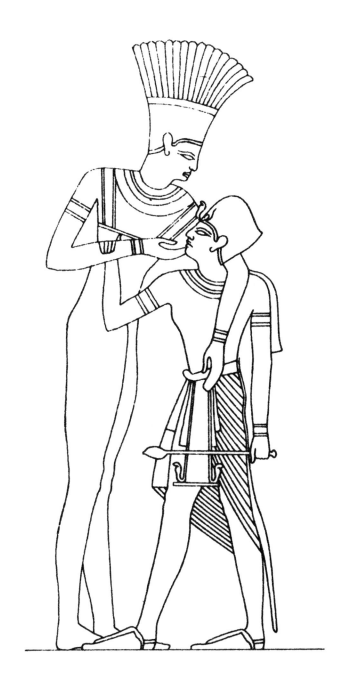

61. A typical Egyptian
figure with torso
seen full face and
head, arms, and
legs in profile.

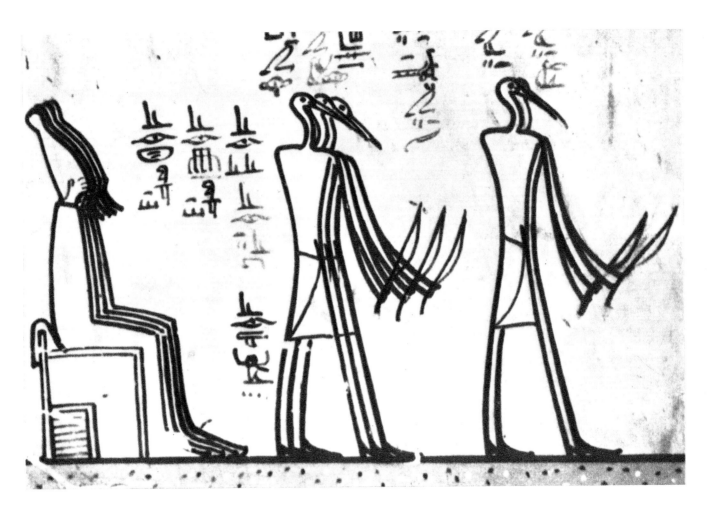

Notice how a sense
of depth is
achieved by simple
overlapping.

62. *Ibis-headed Figures*
Tomb of Tethmosis III
Valley of the Kings,
Thebes

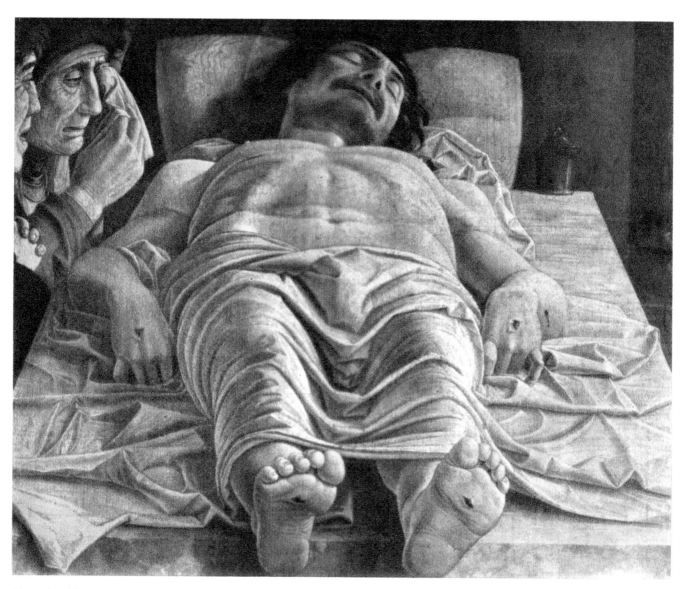

63. Andrea Mantegna
(1431 ?–1506)
Dead Christ
tempera on canvas
Brera, Milan

An early experiment
in foreshortening, and
one of the best.

middle distance entirely, and the background is treated as one plane like a picture within a picture—and that picture in the front plane! On this "background" plane, distant forms are depicted almost entirely in contour-like images scratched on a wall.

Foreshortening is another matter. Even in Egyptian art we find forms ranged in series, one overlapping another, so that progression into depth is suggested. However, the Egyptians held, for many centuries, to a pattern of form which emphasized shape above all. The human figure, for example, was almost invariably represented with head in profile, torso in full frontal view, arms and legs, and hands and feet in profile. This is the easiest, most telling aspect of the figure to read. And nearly all art students begin instinctively to draw the figure in a similar way. The instinct is a sound one, and academic training in foreshortening makes a mistake in treating as a virtue what should be considered as nothing more than a sometimes-necessary evil.

Study the figure of Mantegna's great painting of the dead Christ, an early *tour de force* of foreshortening, and notice the overlapping of forms from feet to head—foot in front of and overlapping the lower leg, lower leg in front of thigh, pelvis in front of torso, torso in front of neck, neck in front of head. But note also the complete absence of perspective here. Camera perspective would have made the feet of this figure enormously large and the head extremely small. Mantegna has kept all his forms in their true proportion—that is to say, in their *felt* proportions. The head in fact is rather disproportionately large because Mantegna wishes to emphasize it as the apex and culmination of his total design.

Use foreshortening and perspective when you must—and avoid them when you can.

8.

Composition

Composition concerns the way in which the elements of a work of art are organized or put together. We have been using the word "form" in a very limited sense to indicate three-dimensional entities. In a larger sense, form indicates the way in which all the parts of a work are related to one another so that the whole work may be a single entity. When we compose, we are seeking some sort of order, unity, and coherence.

Always respect the page, the sheet of paper, on which you draw. To begin with, select a paper that corresponds to the size and shape of the form or group of forms you intend to draw. Don't put small things on large papers or large figures on papers too small to contain them. Try from the beginning to think of your whole page as a space, and visualize, even before you begin to draw, how your forms will be distributed and arranged in this space. In drawing a figure, try to transfer the whole shape to your page in such a way that it reaches toward top, sides, and bottom. To aid in this, study the figure's principal extensions. A seated figure seen in profile should have its back near the edge of your page so that legs and feet have plenty of space into which to extend. Consider the direction in which a figure moves or the direction it looks— the space in front of such a figure is the space into which it can move, and the space behind it is the space it has turned away from. Leave enough space above a head to allow the head freedom of movement and do not let the feet stand on the frame of your picture at the bottom. Make sure that the entire form is contained within the page. Above all, avoid beginning in such a way that your forms will run off the page. It will help to estimate, at the beginning, where the center point of your object or figure is, from top to bottom and from side to side. A figure or object may, of course, be displaced from a central

position on your page if that is your intention—but do this for a reason and not through negligence.

Pay attention to the relation between figure and ground. Draw a figure in a very active pose—leaning, bending, reaching. Draw a leafless tree with branches springing out from the trunk and dividing into a tracery of twigs. Now emphasize the "negative spaces" in these drawings; that is, the spaces between the forms. Develop these spaces, these openings between body, legs, and arms and between interlaced branches so that these negative spaces, rather than the original figure, become your principal pattern. If your figure or your tree was well composed on your page to begin with, these negative spaces will turn out to be well composed too.

Composition involves pattern and rhythm. Keep a balance in your drawing between large shapes and forms and small ones and try to keep forms either large *or* small, avoiding those that are neither, or in-between. Alternate large and small forms interestingly. Don't put all the large ones in one place and small ones in another unless for a specific expressive purpose. Alternate light and dark areas in the same way. Try to distribute light and dark shapes and areas in your drawing so that it is "abstractly" interesting and inviting when seen from a distance. Treat lights and darks in the same way you treat shapes. Contrast large dark shapes with small dark accents and large light ones with sharp, acute small ones.

Rhythm involves repetition which is as important in drawing and painting as in music. Consider the importance in music of "theme and variations," the statement of a motif, and its repetition in varied form again and again. Accident often plays a very important part in any creative activity, but if any element in a work deserves to be there at all, it must be *made* intentional through repetition and development.

Horizontal and vertical lines in a composition are elements of stability. They will give composure, strength, security to a design. Diagonals provide motion, tension, activity. As you use horizontals, verticals, and diagonals in a

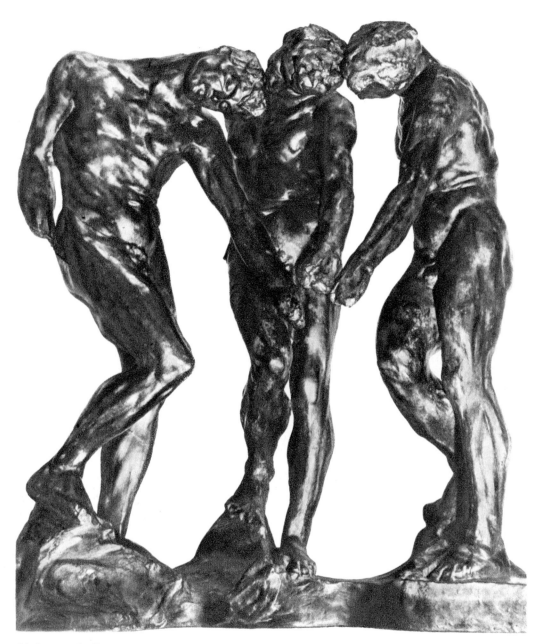

64. Auguste Rodin
The Three Shadows
bronze
Rodin Museum, Paris

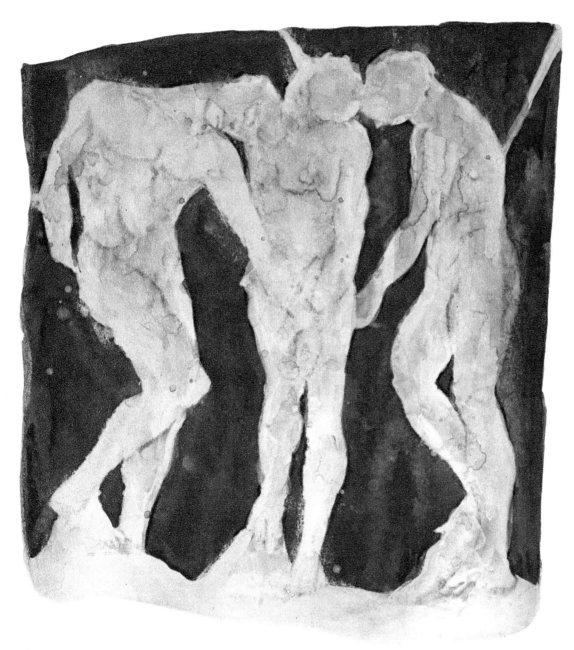

65. Illustration after Rodin's <u>Three Shadows</u>
Make sure that the "negative spaces" in your drawing
form an interesting design in themselves. Transfer
your interest from the shapes and forms of the
object to the shapes of the surrounding spaces

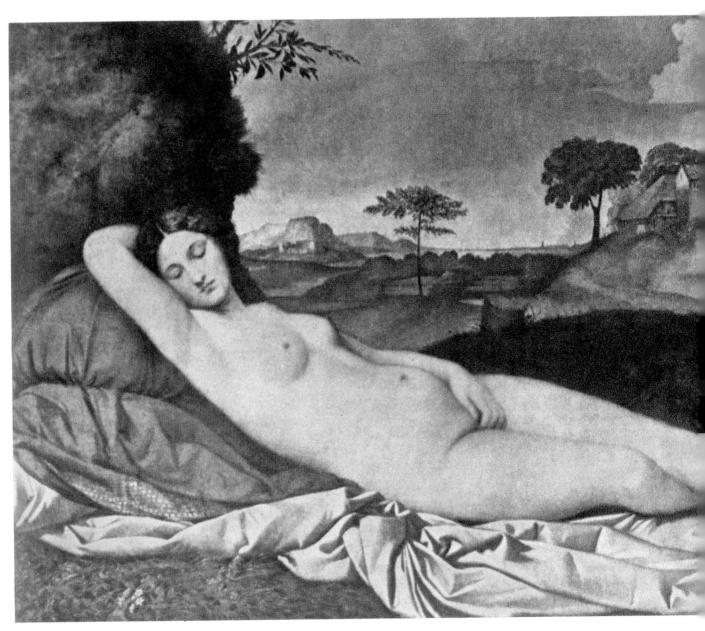

66. Giorgione
(ca. 1477–1510)
Sleeping Venus
oil on canvas
Gemäldegalerie, Dresden

Left unfinished at the time of Giorgione's death, this painting was probably completed by Titian. Note the extreme simplicity of the shape of the figure which is an elongated oval. Giorgione has repeated this oval as a motif with variations throughout the painting, just as a composer repeats a theme with variations. It appears not only in the shapes of the ground forms above and to the right of the figure and in the long cloud at the center, but most importantly, in the drapery which has a playful relation to the figure as it assumes Venus' attitudes: at the extreme left it stretches out like the upraised arm, it gathers together in imitation of the hand at the center, and to the right it crosses just as Venus' knees do. Many artists have imitated this oval form, one of the great archetypes in Western art. Titian repeated this subject again and again throughout his life with minor changes; Ingres' Odalisque is the same figure seen from behind; her last important appearance is as Manet's Olympia.

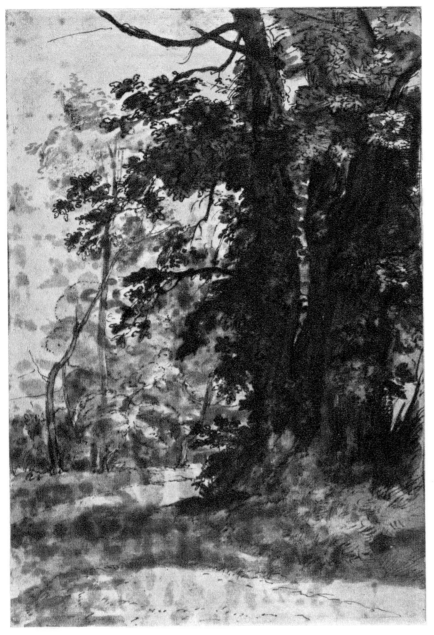

67. Claude Lorrain
(1600–82)
Study of Trees
pen, brown ink, and wash
over traces of black chalk
12 1/8″ × 8 3/8″
British Museum, London

Consider the emphasis on pattern in these works. The simplified and flattened shapes "carry" effectively. Stand back from your drawing and observe it from a distance. Better yet, put it aside but within your vision so that you will come upon it while you're doing other things. Is it attractive and arresting for its pattern, its balance of light and dark elements, even when you cannot make out what it represents?

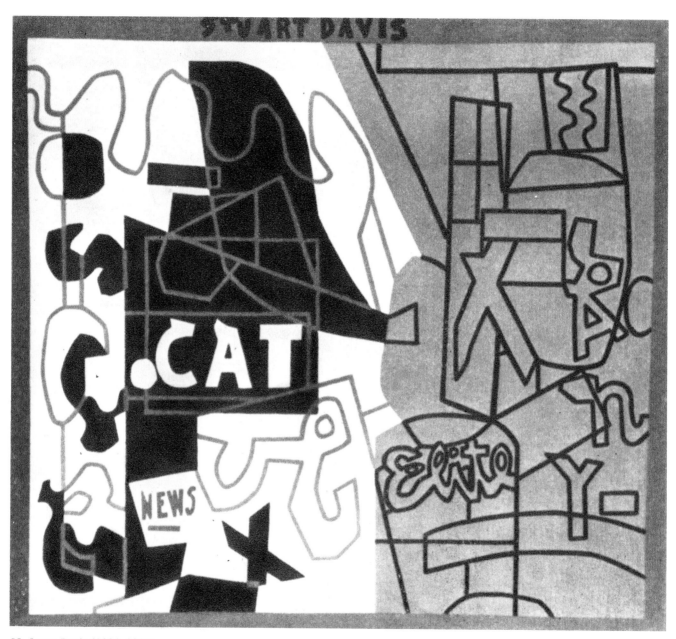

68. Stuart Davis (1894–1967)
Pochade
Collection
Edith Gregor Halpert Estate
Downtown Gallery, New York

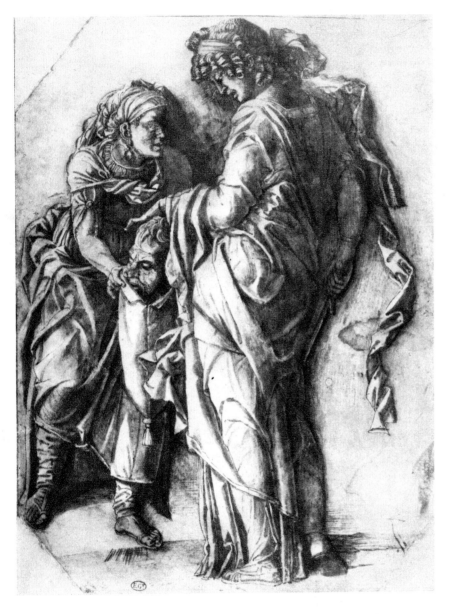

The space or void between the two facing figures is filled by the head of Holofernes which Judith drops into the sack held by her servant. The descending motion of the head between the two upright forms is echoed by the fall of Judith's scarf behind her.

69. Andrea Mantegna
*Judith and the Head
of Holofernes*
drawing
Uffizi, Florence

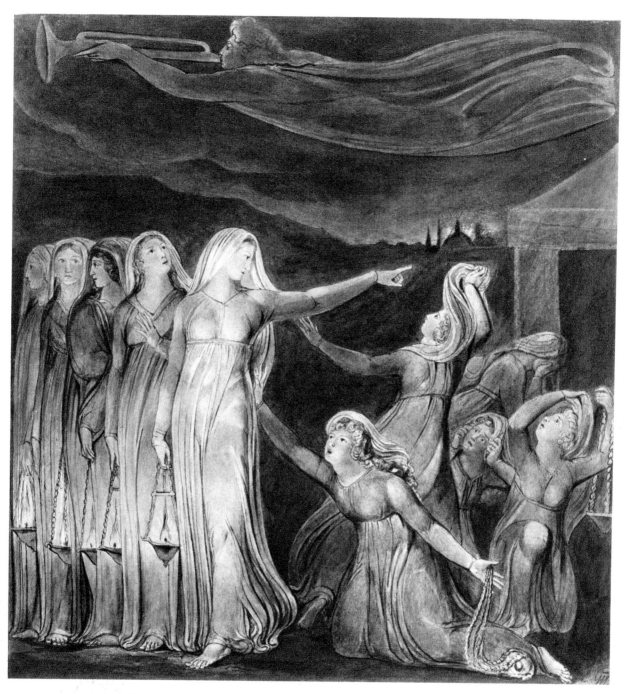

70. William Blake
(1757–1827)
Wise and Foolish Virgins
watercolor with pen and ink
15 1/8" × 13"
Metropolitan Museum of Art
Rogers Fund, 1914

What could be more telling than the contrast between these upright girls with their trimmed lamps, and the pell-mell confusion of the bad girls to the right. The horizontal figure of the angel above makes the verticals of the wise virgins all the more emphatic and thus further points up the scramble of the others.

design, make sure that you repeat them, parallel them with others. The second and third uses of these elements mean that you meant the first one.

In organizing or composing three-dimensional forms, think of your problem in architectural terms. A standing figure or a portrait involves a column of form or a pyramid. Study Leonardo's *Mona Lisa*. Note the basic pyramid form of the figure, the very strong column of form which builds upward at its center from thumb and finger through corner of breast, hair, and scarf to cheek-bone and eye, and the nearby parallel vertical of the nose; the series of arcs in the curve of the wrist, the scarf over the shoulder, the shoulders themselves, the hairline and top of the head; and the inversions of these arcs in the upturned thumb, the line of the blouse, the famous smile and the upward turn of the brow. Note also the series of horizontals—the arm, parapet, the shorelines of the background landscape.

71. Leonardo da Vinci
Mona Lisa
panel, 30 1/4" × 20 7/8"
Louvre, Paris

The *Mona Lisa* is a great example of architectural form. In this apparently simple, but actually very complex design, Leonardo has used two horizon lines or points of view. He had painted the figure as if he is seated below her looking up, and this assumes a low horizon line. Then the landscape behind her is raised as if the artist had stood to draw it. The device increases the importance of both figure and background. The famous mystery of this portrait does not consist in Mona Lisa's smile (Botticelli painted the same smile again and again). Rather it derives from the tremendous landscape development behind the figure, a forward-moving progression of which the figure is the culmination.

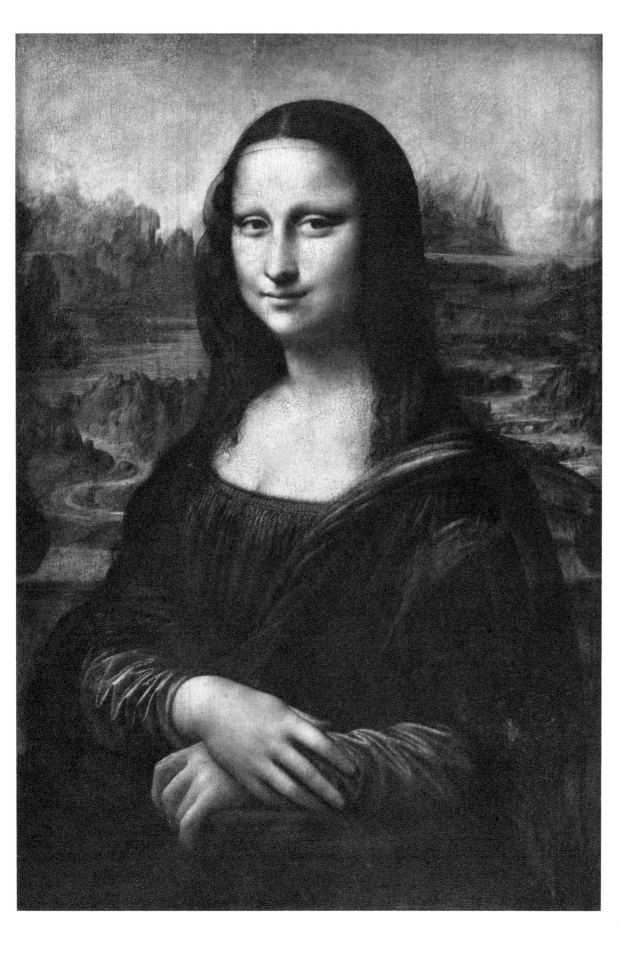

Study the compositions of the great artists. These works are available to everyone today in the form of excellent reproductions. Analyze these compositions by sketching them freely. Search out the forms and shapes which make up the picture. Investigate the ways in which the artist has distributed these shapes and forms over the picture surface. For example, study Titian's *Adam and Eve*, in the Prado Museum in Madrid. Note the pyramidal design which culminates in the apple in Eve's hand at its apex. Consider the way in which the figures of Adam and Eve parallel each other as diagonals from upper left to lower right, and note the balancing diagonal of the tree. Study the way in which the arms and legs bridge the space between the figures and note the spiral movement of all the forms about a central axis. The location of this axis is indicated by the tree, but it is actually invisible—it runs in front of Adam's extended leg and arm and behind the extended arm of Eve.

Study the manner in which Titian has drawn these figures so that their shapes "read" at a glance. He has given them an almost Egyptian simplicity with heads in profile, torsos in full face, arms and legs in profile.

Notice the clarity with which Titian treats the spaces between his principal forms—those areas which are sometimes referred to as the "negative spaces" but which in good design are never negative at all. It will help you to understand the true importance of these spaces if you will sketch in such a way that these openings between the forms, these interstices, become main shapes rather than subsidiary ones. (Let the space between Adam's arm and body, the space between his legs, the space between his leg and Eve's become positive. Pull these shapes forward and treat the forms of legs and arms and torsos as negative.) In this way you will discover that if a design is well balanced, there is as much interest in these intervening shapes as in the "main" ones.

Compare Titian's figure of Adam with Michelangelo's figure of Christ in the *Pietà* in Florence. Compare both of these with Myron's *Discobolus*. Then consider Rubens' copy of this Titian painting (also in Madrid). Rubens

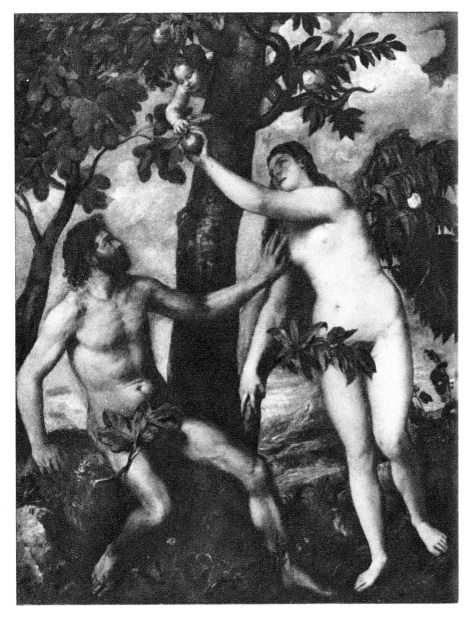

The figure of Adam
is presented
planimetrically,
almost like an
Egyptian figure.

72. Titian
Adam and Eve
Prado, Madrid

TITIAN
ADAM

MICHELANGELO

PIETA

73. Three examples
of planimetric
design (after Titian,
Michelangelo, and
Myron) in which
simple shape tells
the story in the most
effective way.

MYRON

Rubens altered the posture of Adam, turning the figure from a frontal to a side view. It is a great *tour de force* on Rubens' part because this is the most difficult aspect of the figure to draw, but the Titian figure is the stronger of the two

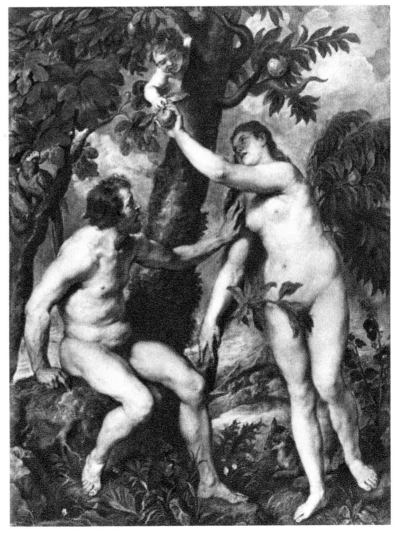

74. Peter Paul Rubens
The Original Sin
(copy after Titian's
Adam and Eve)
Prado, Madrid

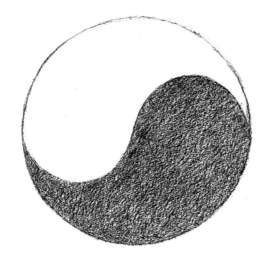

75. *Yin and Yang*

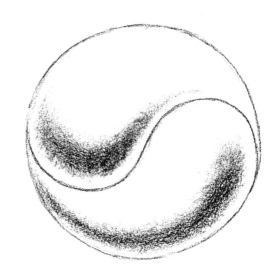

The Chinese symbol of unity, achieved through the balance of conflicting or complementary forces. In black and white, these two elements form a divided circle; with the addition of modeling they produce a sphere. A circle or sphere constitutes the most "perfect" form we know because each encloses the greatest quantity within the smallest boundary. The ancient Chinese symbol perfectly expresses resolution or reconciliation and balance.

"improved" upon the original and turned Adam's figure toward Eve so that his side is presented to the spectator. Now this aspect of the figure is more difficult to draw than the frontal view, and Rubens (who was young at the time) demonstrates his skill with great virtuosity. But the result is far less compelling than the Titian figure.

In Baroque art, for example in the work of Tintoretto and Rubens, the Renaissance stability of a work like the *Mona Lisa* becomes an architecture of unstable equilibrium. The column is there, but as an invisible center of gravity around which forms move spirally in a series of thrusts and counter-thrusts. A long horizontal composition is unified by the repetition of these axes at intervals through the whole design, with the forms revolving about these centers and swinging from axis to axis. Perhaps the Chinese, who knew everything, made the perfect symbol of this unstable equilibrium in their emblem of the Yin and Yang. In this symbol of duality, denoting male-female, active-passive, and so on, opposing elements form, through their thrust and counter-thrust, a perfect self-contained entity, a circle or sphere.

Apply this principle of thrust and counter-thrust to a design such as that of the Titian *Adam and Eve* which we have been considering. Study its development in the work of Rubens.

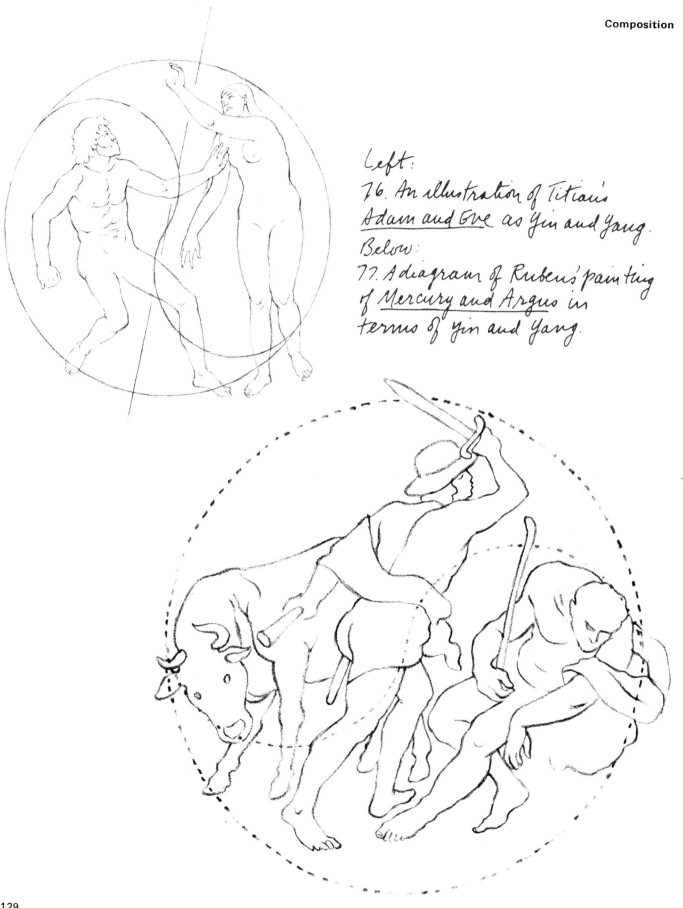

Left:
76. An illustration of Titian's
Adam and Eve as Yin and Yang.
Below:
77. A diagram of Rubens' painting
of Mercury and Argus in
terms of Yin and Yang.

9.
Drawing the Human Figure

Learn to divide the body, at its principal joints, into its basic masses or members. Begin with the torso and pelvis and represent these as flattened cubic forms or boxes. The torso is the rib cage or thorax and the muscles which cover it, and the pelvis is the hipbones with their musculature. These masses are joined by the spine and together they form the trunk of the body. The spine which connects them can rotate round its own axis and can bend backward, forward, and sideways.

Represent the arms and legs as cylinders: a cylinder for upper arm from shoulder to elbow and another from elbow to wrist; one from hip to knee and another from knee to ankle. Represent hands and feet as flattened blocks or paddles. Represent the neck as a cylinder and the head as an egg-shaped mass, narrower at chin and fuller at top.

Draw this mannikin for yourself in various positions until you have familiarized yourself with its sixteen basic parts. With the aid of anatomy charts, draw the skeleton within this diagrammed figure. Over the skeleton draw the principal muscles. Sketch this mannikin in various attitudes, and over this framework sketch clothing. Train yourself to *see* these basic forms underlying the clothing of people around you.

In drawing the figure, begin with any part of the body, but try to grasp it as a whole from the beginning. Place the body, with all its extending members, on your page quickly and lightly. Then draw the trunk—torso and pelvis. This is the most important part of your figure. Treat arms and legs, hands and feet, and head and neck as accessories which attach to this trunk as extensions of it.

Nearly all beginners start with the head, or even with the features, and make these disproportionately large—the features (or face) too large for the head and the head too large for the body—like Jimmy Durante's nose ("My nose was born and I grew on to it"). Begin with the head, if you please, but indicate it very lightly, omitting all features, and proceed to sketch in the whole body. Then

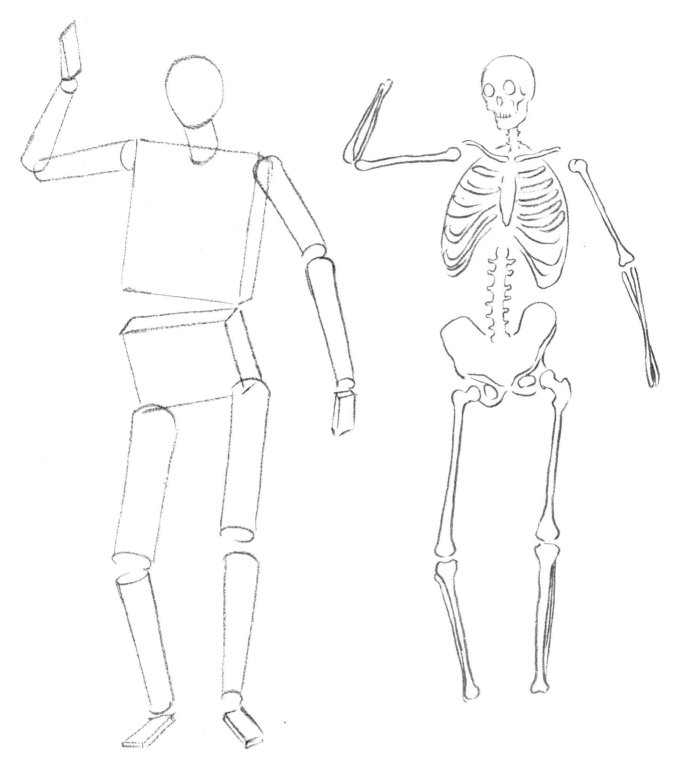

78. The human figure divided into sixteen parts.
In drawing the figure, keep your contours convex,
not concave. A convex line conveys a sense of pressure
from within. Concave or straight lines look deflated.
79. The principal elements of the skeleton.

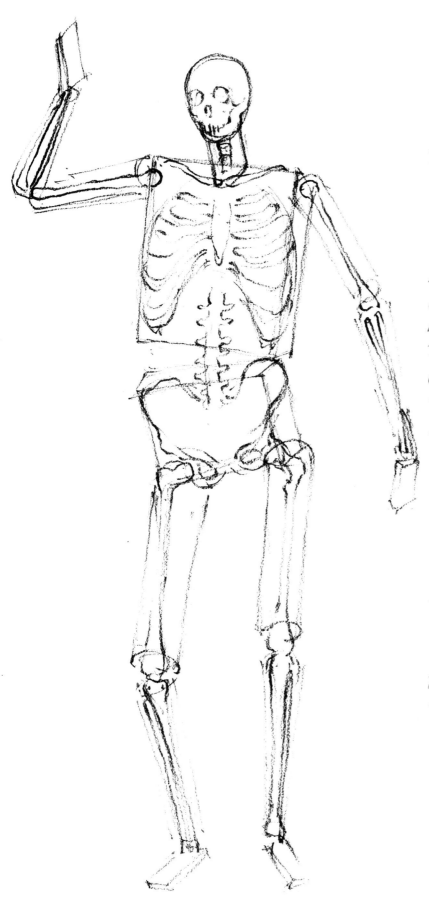

80. The skeleton within the mannikin.

81. Mannikin in various attitudes. Take these sixteen parts of the figure and draw them in many different attitudes. The trunk consists of torso (rib cage) and pelvis. These two bony masses are joined together by the spine. The arms are attached to the shoulder blades at the top of the rib cage. The legs attach to the pelvis with ball-and-socket joints. The neck is a continuation of the spine. Concentrate on drawing the torso and pelvis, then add arms, leg, neck, and head.

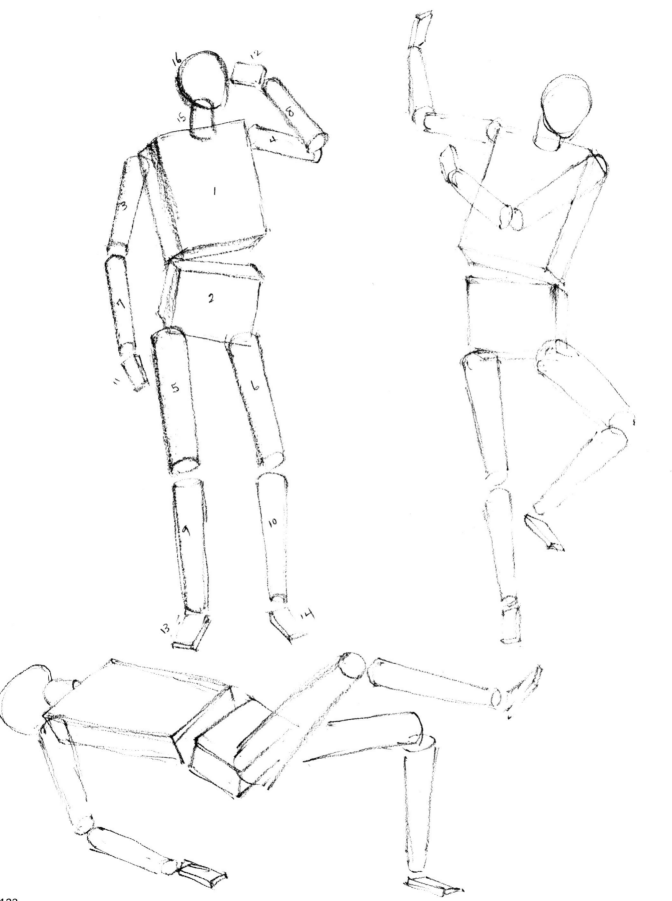

133

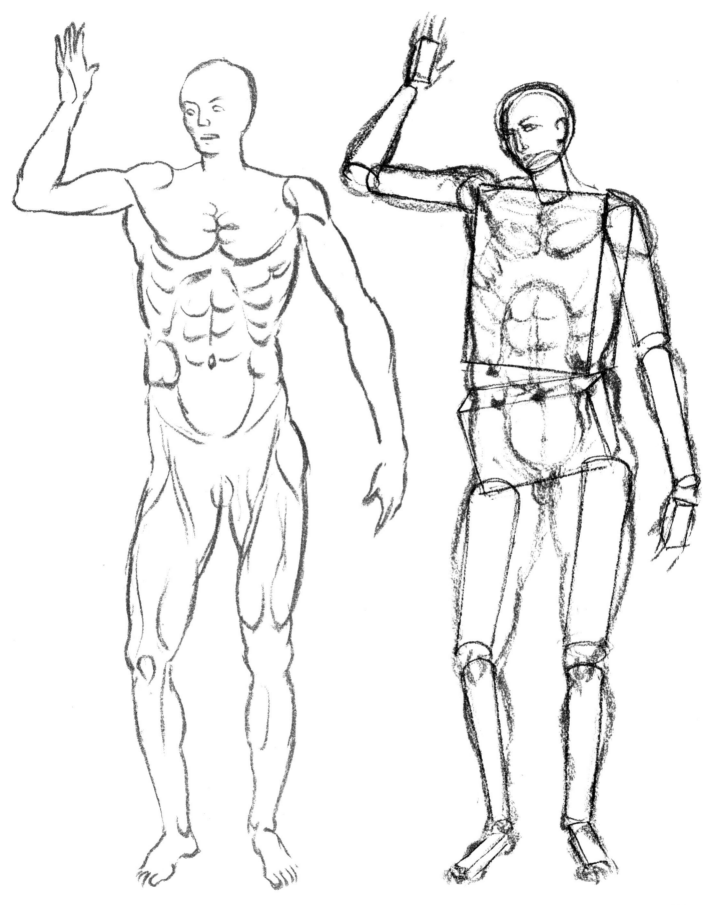

82. The musculature of the body. Using an artist's anatomy book as your guide, make a rough simple drawing of the skeleton in its main parts. Then draw the muscles over the skeleton using crayon or ink of a different color.

83. The muscles of the body within the sixteen-part mannikin.

proceed first to develop the trunk. Then draw the extending members. Draw the big things first. Last of all draw the small ones, fingers and toes, eyes, nose, and mouth, ears, nipples, navel, finger and toe nails.

Draw the head as an egg and write in the features as if you were drawing them with a pencil or pen on a hen's egg. Study the form of the skull (refer to a skeleton if you can find access to one in a medical or art school, or study its form in the plates of an anatomy book). "Likeness" begins with this bony structure of the skull, its general shape, the width of its cheekbones, the character of the jawbone.

All contour lines in the body are convex, never concave. If you think you see a concave contour line you will find on closer study (feeling) that it is in reality a series of convexities.

These contours must be convex so that they will convey a sense of pressure from within. A straight or concave line will look collapsed, deflated. The sculptor Mahonri Young used to say that he could always tell a Greek sculpture from a Roman because the Greek figure was taken on the inspiration, the indrawn breath, the Roman on the expiration. Remember that the atmospheric pressure at sea level is fifteen pounds to the square inch and the surfaces of the human body must meet this pressure with equal force at every point.

Let arms and legs bow outward slightly. Let arms curve outward slightly in conformity with the outward curve of the sides of the figure. Let them enclose the body. The legs support the whole weight of the body, and this support is better maintained by this: () than by this:) (. Try in drawing arms and hands, legs and feet, to achieve a total gesture which begins at shoulder or hip and flows

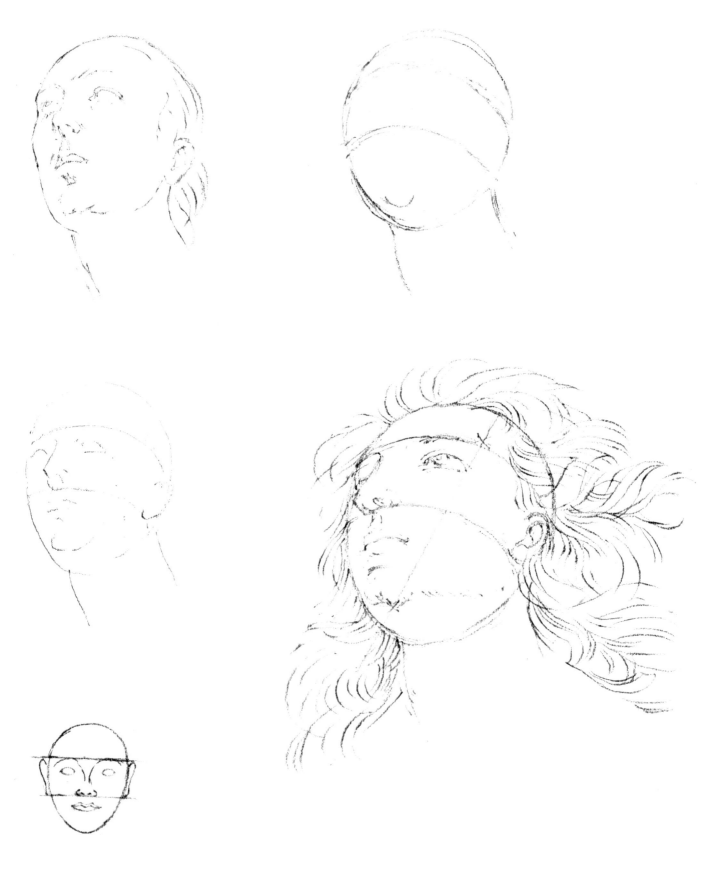

136

85. Raphael
Head
British Museum, London

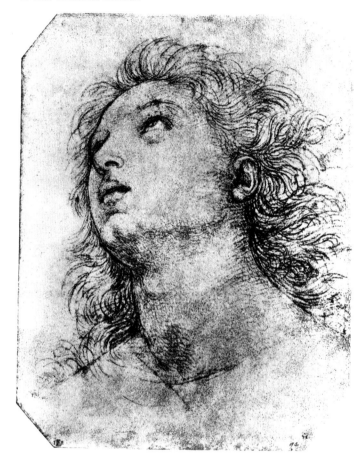

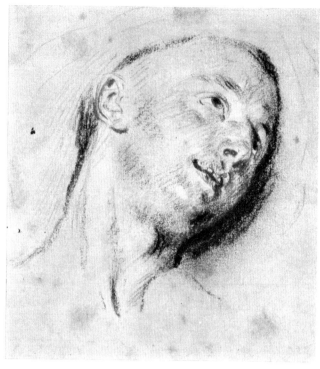

86. Jean Antoine Watteau
(1684–1721)
Study of Head
Metropolitan Museum of Art
Rogers Fund, 1937

84. Divide the head into three equal parts. Place
the brow on the top line, the bottom of the nose on the
lower line. Place the ears, like the nose, between
upper and lower lines on the middle band. Treat
the head as an egg-shaped mass with the cranium
at the larger end and the chin at the narrower.
Draw two bands at equal distances around this egg,
then tip the egg upward and downward. Notice
that with an upward inclination, the line of the
brows moves toward the top, that the nose rises
with it, while the ears descend following this
middle band.

NOT THIS — THIS —

87. Always use convex lines instead of concave.

uninterruptedly to finger or toe. Fingers and toes should round off into a single point and not be squared off. Study this use of total gesture by sketching a classic example such as the arms and hands in Michelangelo's *The Creation of Adam* or Dürer's *Praying Hands.*

Above all, in drawing the human body, make the trunk (torso and pelvis) the expressive part of the drawing. Michelangelo said that a sculptured figure should resemble one which has been rolled downhill and had arms and legs and head knocked off. And he is said to have learned his art from the headless, legless, and armless *Belvedere Torso,* a Greek work now in the Vatican Museum. This sculptural fragment treats the trunk of the body as a portrait painter treats the head.

Above all, form an opinion about the figure you wish to draw, whether you are drawing from a live model or from memory or imagination. Contemplate this figure and decide what it means to you. Ask yourself: "Do I want to draw this? Why? What is interesting about it? What does it say?" Then try to draw *that.*

Study the gesture, the action, for what it expresses of mood, character, and drama. Recall again Leonardo's advice regarding the sign language of deaf mutes. Every visitor to Italy observes how rich a language of gesture

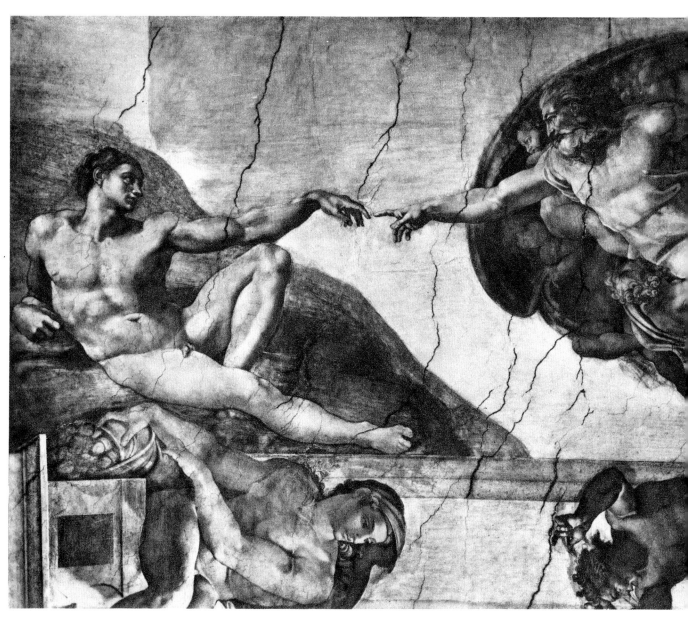

88. Michelangelo
The Creation of Adam
fresco
Sistine Chapel, Rome

In this great painting the gesture is everything

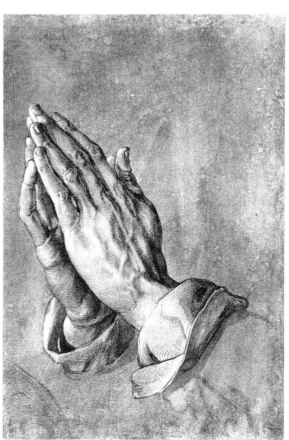

89. Albrecht Dürer
Praying Hands
Albertina Collection,
Vienna

Another great
example of gesture.

the Italians possess. The northern Europeans and Americans are considered to be less expressive in their gestures than the Mediterranean peoples, but an American psychologist has recently written about the "body language" we all use without conscious awareness. Our postures and gestures are full of meaning, and the artist must be alert to these.

This language of the body changes just as spoken language does. The old gestures of the "Delsarte" school, which young ladies were taught in the nineteenth century, were already conventional when they were formulated. These were the broad gestures of the nineteenth-century theater and the early silent movies: the back of the hand to the forehead, the eyes rolled up to heaven. The introduction of sound, color, and improved camera technique made this pantomime seem quaint for a time, but as the cinema has matured, these ancient methods prove persistent. Certain gestures, however, like certain turns of phrase, become worn out with use, and an artist, like an actor, will avoid them and search for fresher and more revealing ones.

The problems of portrait drawing are the same as those of the figure as a whole. The beginner nearly always puts the cart before the horse and concentrates on the facial features, the eyes, nose, and mouth. These he overworks, while at the same time he neglects the head. As for the body which supports the head, he has run out of ammunition long before he remembers it's there. Bear in mind that the face is a small part of the head. The bony structure of the head determines its form and its principal characteristics, those elements which constitute a "likeness," such as wide cheekbones or narrow, square jaw, or receding chin. The head is supported by a neck which is long or short, massive or delicate, and the neck arises from shoulders which are broad or narrow, hunched or tapering. The flare of the nostril, the curl of the lip, the glint in the eye, these are the last touches to be added to a portrait, not the first. The best preparation for drawing or painting portraits is figure drawing.

Similarly, hands and feet should be studied for themselves but only after the artist has learned to deal with

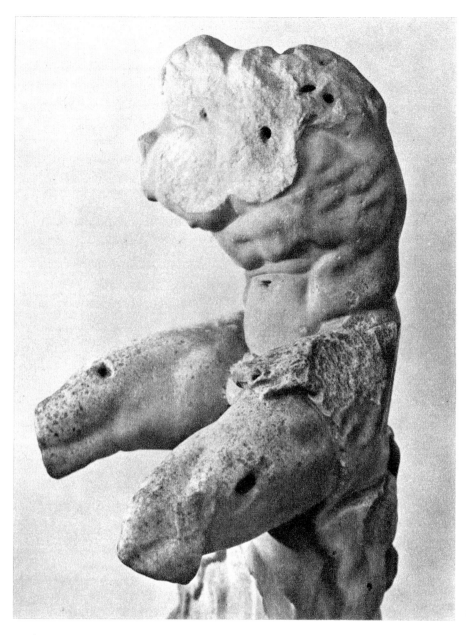

90. *Belvedere Torso*
(ca. mid-first century B.C.)
marble, 5', 2 5/8"
Vatican Museum, Rome

This fragmented torso was copied by Michelangelo
when he was a young man. The nude youths
on the Sistine ceiling all derive from it.
Michelangelo probably had this torso in mind
when he said that a sculptured figure should
look as if it had been rolled down hill and
had had its legs, arms, and head broken off.
What he learned from this figure was that the
trunk of the body must carry the expression,
not merely the face and hands.

the figure as a whole. Again, action and gesture are the key to the problem. Study the expressive uses which dancers make of their hands and feet. In portraiture, hands are very important; they can amplify and confirm the character of the face. They can even contradict and expose it.

Hands should be made to gesticulate. Even in repose they should be given a sense of direction. In general, remember to lead the fingers to a single main point and avoid cutting them off squarely like a shovel. Even feet can be made to move and to take expressive attitudes. Shoes have maimed the human foot and nearly paralyzed it, but the artist can reassert its prehensile capabilities.

Study the expressive uses of the hands in the work of great artists. Notice how the hands of Titian's *Pope Paul III* (in the Naples Museum) play a double role. One is relaxed and gentle; it could make a benediction. The other is rapacious. The hands play a great part in making this one of the finest portraits ever painted.

Look at Ingres' portrait of the banker Bertin. In this case, the subject of the picture has left us a very revealing account of the artist's procedure. He tells us that when he first visited Ingres' studio to sit for him, the artist tried time after time but could not get it right. Finally, he flung down his pencil and burst into tears. Bertin put his hand on his shoulder and assured him there was plenty of time and that he would return as often as necessary. Then one day he was at a party where Ingres was present. Suddenly Ingres rushed over to him and said: "Come tomorrow. I've got it." He had observed Bertin sitting with his fingers on his knees. From that time everything went forward.

To draw the figure well you must acquaint yourself with its structure, the bones and muscles which compose it. Copy good drawings in order to learn what the artist was doing. Make free transcriptions of the figure drawings of Michelangelo, Leonardo, Raphael, and Rubens. Do this with a good artist's anatomy book at hand. Ask yourself what the bumps and hollows in these drawings mean. Search out, in the anatomical plates and diagrams, the bones and muscles which Leonardo and Raphael are indicating.

The problems of landscape drawing are very similar to those of figure drawing. The beginner makes the same mistake he makes in drawing a face, that of drawing eyelashes and leaves before he has drawn a head or a tree. To begin with, explore the earth forms, the large masses of hill and valley which underlie the whole scene. Foliage of all sorts grows out of these basic forms as hair grows from the body. Draw a tree with the same kind of exploration you give to a figure. Regard the trunk and branches as the tree's supporting skeleton, its masses of foliage as its flesh and muscle. See the landscape in terms of large simple masses. Subordinate details to the big forms of which they are a part. Don't fail to see the forest for the trees.

The first serious drawing criticism I ever had came from John Sloan, who looked over my shoulder, in his class at the Art Students League, at the tight, niggling drawing I was making. "That's jail work!" he said. "It looks like something the old man was doing when he died!" It shook me up and I have never forgotten it. To this day it comes to mind when I find myself lapsing into cramped tightness and I remember to be bolder and looser in my

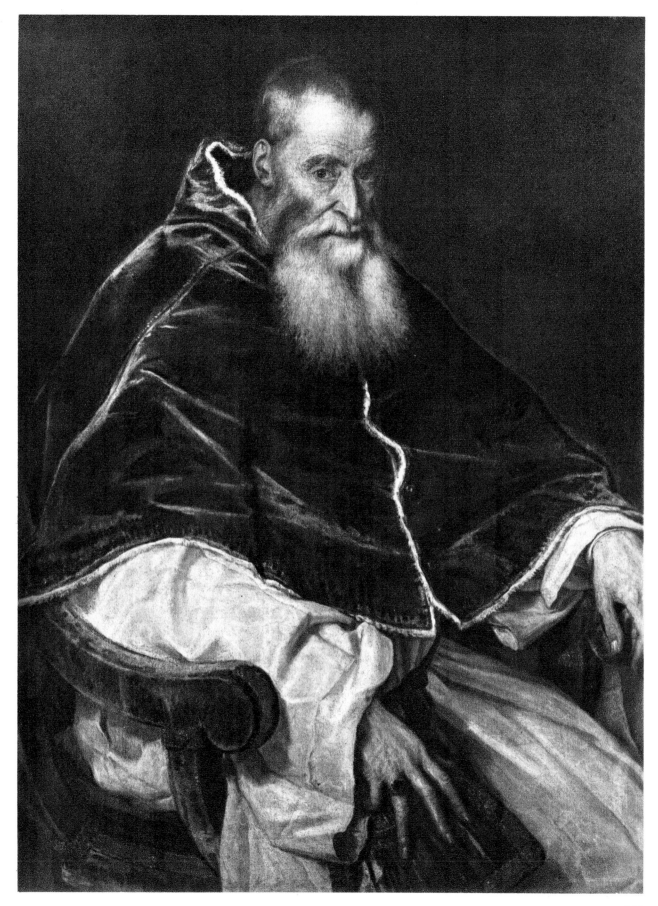

In this portrait, the personality which is expressed in the head of the old man with his intense sideways glance is greatly reinforced by the character of the hands. One rests in a relaxed attitude on the arms of the chair, the other clutches; they contradict each other.

approach. We all have our personal manners, our peculiarities and idiosyncrasies. These are, ultimately, our *style*. But we should guard against this style crystallizing too rigidly, too early. Do not settle for "doing your own thing" until by experiment you have determined beyond a doubt that it is your own. If anything about drawing frightens you because it seems too difficult, make that the very thing you tackle immediately until your fears are overcome. The earlier you fight these battles, the easier it will be to win them.

If you can draw the human body, you can draw anything. Maybe it is not your subject, and while it is important for an artist to know his limitations, it is often true that the very thing he can't do turns out to be what he does best. I recall Thomas Hart Benton's response to a question put to him years ago regarding Jackson Pollock, who had been his pupil. Benton, who never says an unkind word about a fellow artist, hesitated a moment, then said, "Well, Jack always had a wonderful sense of color. But he couldn't draw." I'm sure that in a sense this was entirely true and that Pollock would have been the first to say so. And yet he went on to do important work which I think any perceptive person will agree is *nothing but drawing.*

91. Titian
Portrait of Pope Paul III
oil on canvas,
41 3/4″ × 33 1/2″
Museo di Capodimonte, Naples

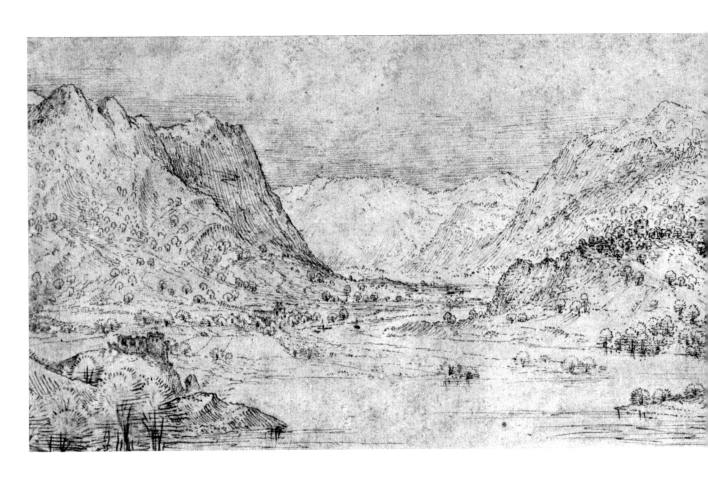

In this landscape, Bruegel has drawn the forms of the earth very strongly — its mountains and valleys, hills and gullies. The trees and grasses grow out of these underlying forms.

92. Pieter Bruegel
(1525/30–1569)
Ticino Valley South of the
St. Gotthard Pass
drawing, 5″ × 13″
Kupferstichkabinett, Dresden

93. Thomas Hart Benton
(1889–)
Diagrams describing
principles of
form organization

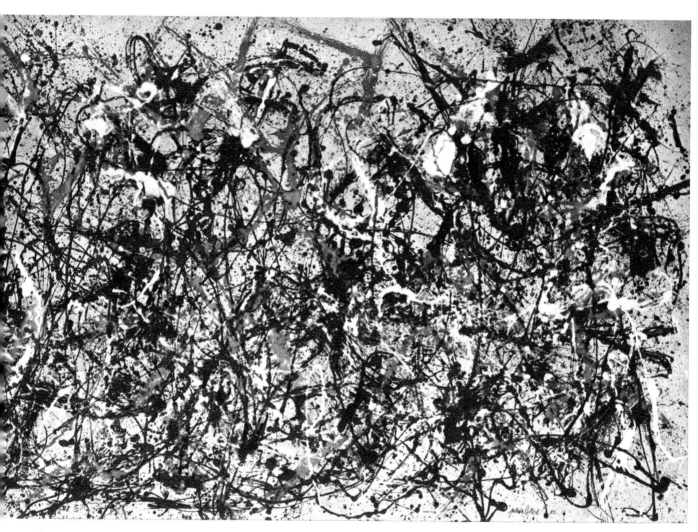

94. Jackson Pollock
(1912–56)
Autumn Rhythm
oil on canvas
105″ × 207″
The Metropolitan Museum of Art
George A. Hearn Fund, 1957

Compare the painting by Pollock with the series of diagrams made by his teacher, Thomas Hart Benton, to illustrate a series of articles which Benton wrote on the subject of "form organization." Benton's diagrams were, for Benton, guidelines to the distribution of forms in space; for Pollock these guidelines became ends in themselves.

10.

A Great Drawing

This drawing by Rubens was a study for a painting, *Daniel in the Lion's Den*. It is drawn with black and white chalk on gray paper.

Notice the great fullness and variety of the contours throughout this drawing. Consider the contours of the hair alone. A few lines give it springiness and movement and texture. Its paleness, together with the Flemish type of the head as a whole, suggest that it has a blond color.

Follow the contour from neck to end of collarbone, over and around the shoulder and along the muscles of the upper arm toward the elbow, and observe the variations in its strength, its weight, its lightness and darkness. At the high point of the shoulder the light on the rounded top of this muscle carries across the contour so that the contour is almost lost, while at the bottom of the shoulder it darkens with the tone which models the muscle. It lightens again with the muscle of the arm and then once more intensifies where the muscle turns in, just above the elbow.

Note how throughout its length this outer contour of the arm from shoulder to elbow is *on* the arm while from the elbow upward toward the hand it is *behind* the arm, up to the point where the forearms meet. At this point the contour disappears behind the contour of the other arm. Then when it reappears again, the contour is once more on the arm itself. Notice how this variation signifies that on shoulder and forearm the arm is slightly darker at its edge than the background behind it; beyond the turn at the elbow the forearm is lighter, with reflected light, than the body behind it; then at the opening between the wrists, the wrist is darker than the body.

95. Peter Paul Rubens
Seated Nude Youth
(Study for
Daniel in the Lion's Den)
The Pierpont Morgan Library

96. Peter Paul Rubens
Daniel in the Lion's Den
88″ × 130 1/8″
National Gallery of Art,
Washington, D.C.
Alisa Mellon Bruce Fund

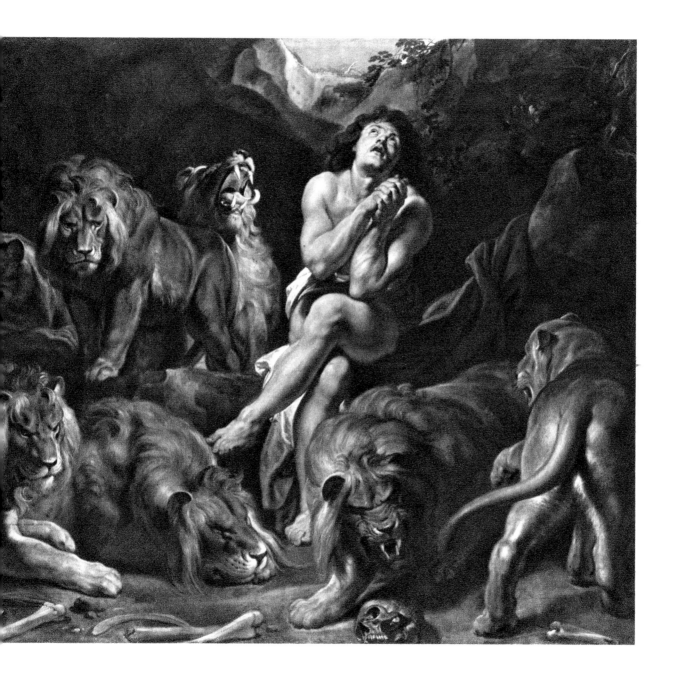

Notice that on the other side of the figure (the right side of the drawing), the contour is behind the body at two points—just above the shoulder and along the side beyond the forearm. But not along the shoulder. The contour is almost lost here, and this is an element in this drawing which we will come to in a moment.

Let's first consider the total composition of this drawing. It has a very strong central axis which runs upward from the crossing of the legs through elbow and arm to the clasped hands, chin, and head. Across this upward vertical sweeps a series of strong diagonals—the initial thrust of the leg from lower left of the page to the knee; another through arms to clasped hands; finally, the parallel thrust of the head. Around the central axis turns a mounting spiral movement—across the foreshortened thigh into the drapery which sweeps around the whole figure at the hips, up into the shoulder at the left side of the drawing and across through the writhing hands, then up into the agitated hair and around the head.

Notice how the strongest accents in this drawing pull forward toward the center—the strong dark of the shadow cast by the arm against the thigh; above this the accent on the projecting knuckles of the clasped hands; finally, the sharp accents of the features. Notice also how the forms in the lower half of the drawing, the projecting thigh and knee and the central forearm, are held forward by being kept light with the dark behind them; how this is reversed in the hands above, which are strongly silhouetted against a light which establishes the shelf of the whole top of the torso at chest and shoulders; and, finally, how the head uses both these means to achieve a climax, with the total form of the head light against the dark of the hair. In the head, the features receive the darkest accents of the whole drawing. This holds them in front of the light form of the head which is projected

against the dark of the hair which, in turn, is silhouetted against the light of the ground.

This brings us to the most important technical element in this masterful drawing—the device by means of which all these powerfully moving forms are unified—and that is the almost incredible dexterity with which Rubens handles that tone which I have described as the third contour, the turn of the form. Follow this corner where it enters the drawing below the knee. It continues upward to the knee joint and is carried around the thigh into the shadow cast by the arm at the elbow. It pins down the elbow joint, articulates it, then sweeps upward along the contour of the arm and loops breathtakingly over the shoulder and back to the forearm where it climbs to the hands and reaches a kind of denouement at the tensely clenched knuckles of the hands. From the hands it ascends through the center of the neck, defining larynx and chin, runs up along the cheekbone to the brow. Then eyebrow and bridge of nose divert it to the single isolated accent of the figure's right eye. And this eye, the culmination of the central axis of this whole design, points sharply upward, and the glance carries the whole movement into infinity.

Once we are caught up in this movement we are carried with it irresistibly throughout the whole complex design. Everything is subordinated to this inner contour, the continental divide which runs infallibly along the highest line of projection from bottom to top. Rubens rides this crest of the wave with the triumphant skill and impetuosity of a surfboarder. And in Rubens' case, his swelling tide is a piece of paper.

11.

Conclusion

I hope this book may provide the beginner in drawing with a course of action. The basic exercises I have described are those which I have found most important in my thirty years of teaching drawing. These ideas are not original with me. (Nothing any of us can do is original—be assured of this.) I learned them, in essence, from my own teachers, principally John Sloan. Over the years, however, I have modified what I learned from my teachers as I have tested those inspired instructions in my own work as artist and teacher.

To this degree, then, this is a "how-to" book, but it aspires to be something more and to deal with the questions of *what* and *why* as well as *how*. The author believes that art can only be studied effectively in a cultural context and he has attempted here to provide a philosophical basis for technical procedure. These philosophical concepts used to be provided by tradition, and artists learned them in their earliest years much as they learned to speak their native languages. In recent years, this traditional knowledge is not automatically available and has to be consciously sought for.

If the reader will reflect for a moment, I am sure he will agree with me in this matter of the importance of tradition. Consider the means, the tools, we use in drawing and painting. Primitive man probably discovered a medium which we still use—charcoal—when he picked up a piece of charred wood and made marks on the wall of his cave. A child today can make the same discovery for himself. But who, without some instruction, is likely to collect wild hog bristles from Outer Mongolia, sort them for length and resilience, bind them together in a metal ring or band, and attach the band to a stick and thus invent the brush? To learn to mix iron oxide or other pigments with binding mediums like oil or gum or

casein, and with a brush to apply the resulting inks or paints to prepared surfaces like paper—all this is unimaginable without a long traditional preparation. A brush or a tube of paint is the embodiment of extremely complex lore, and its use requires some understanding of the reasons behind its invention.

The author's effort in this book to give technical practice a philosophical basis is not original either. I had the good fortune to study with Kenneth Hayes Miller, another great teacher, whose understanding of the "Old Masters" of the European tradition was profound. This understanding had nothing to do with "Art History," about which Miller cared very little. He seemed to regard all the greatest artists as having been in friendly touch with each other in the not-too-distant past. But he could "read" a painting and analyze a pictorial composition as a great musical conductor can read a score.

I often tell my students that everything I know about the technical aspects of art I can tell them in three weeks, but that they will not grasp it in that length of time. In Miller's case, he had a way of talking over his student's heads which was bewildering to a beginner. "Never paint anything you didn't touch as a child," was clear enough. But: "to understand a form plastically is to comprehend its inner character and its position in nature"—this was more difficult. It was only in relation to practice that his ideas acquired meaning. I think that the study of art must proceed on these parallel paths, with its philosophy informing its practice and its practice embodying its philosophy.

I would like this book to be an accompaniment to practice and I hope the student who reads it will follow its recommendations with patience, concentration, and pleasure.